PREFACE TO THE SECOND EDITION

FIGURES 2 and 6 have been redrawn, a confusion, which passed unnoticed through the press, having arisen between the lettering of the diagrams and the references in the text. Still less excusable is my omission to recognize publicly the fact that the whole idea of the book was not due to me but to Mr. Archibald Marshall, the novelist.

To this second edition has been added a slight historical outline of the development of modern painting. With the exception of examples by Van Gogh, by Henri-Matisse, or of cubistic methods, Chapter X will be found to contain the major part of the strictly necessary matter illustrative of the added text. It has been thought useful to call attention in this way to the origins of that aesthetic position to which, however non-professional he may be, the modern sketcher cannot remain wholly a stranger. The thing is ambient, from its influence we cannot escape.

V. B.

LES BAUX-EN-PROVENCE.
March 1929.

TABLE OF CONTENTS

PAGE

INTRODUCTION 1
Aesthetic and practice of sketching. Reason of the summary frontis-
piece. Turner. *Enveloppement.* Sketching as an aid to appreciation
of painting. Importance of the seemingly unimportant. All-
importance of interrelation. Necessity of drawing.

CHAPTER I. PERSPECTIVE 7
Perspective a comparatively recent subject. The sketcher must not be
quite ignorant of its elements. Horizon line. Vanishing points.
Circles. Arches. Sloping roofs. Trees in perspective. Importance
of shadow shape. Vanishing point of shadows. Reflections. Limits
of reflection. Ripples. Double point of sight.

CHAPTER II. ON LANDSCAPE DRAWING . . 18
Laws of natural shapes. Study of the nude as a school for drawing.
Hill and mountain forms. Solidity in drawing. Rhythm in drawing.
Drawing is seeing the relative importance of facts. Rock drawing.
Tree and plant form. Their immediate causes are the opposites from
those of mountains. Vital lines. Branches. Truth in drawing
foliage masses. Plants. Necessity of 'understanding' the subject
of the picture. Ground-plan of the picture. Decision in drawing.

CHAPTER III CHOICE OF SUBJECT AND COMPOSI-
TION 26
Difficulty of choice of subject. The real subject need not take up much
of the picture's area. Simplicity in choice. Modification of composi-
tion. Why composition is needed. Balance of composition. Nature
furnishes balancing elements. Goodness of a sketch depends most
largely on understanding the relative importance of its elements.
Bad composition choice a fruitful cause of failure. Importance of fore-

THE
WAY TO SKETCH
With Special Reference to Water-Colour

Vernon Blake

Dover Publications, Inc.
New York

Published in Canada by General Publishing Company, Ltd., 30 Lesmill Road, Don Mills, Toronto, Ontario.

Published in the United Kingdom by Constable and Company, Ltd.

This Dover edition, first published in 1981, is an unabridged republication of the second (1929) edition of the work originally published by the Clarendon Press, Oxford, in 1925 under the title *The Way to Sketch: Notes on the essentials of landscape sketching; particular reference being made to the use of water-colour.* This edition appears by special arrangement with the Oxford University Press.

International Standard Book Number: 0-486-24119-X
Library of Congress Catalog Card Number: 80-83668

Manufactured in the United States of America
Dover Publications, Inc.
180 Varick Street
New York, N.Y. 10014

ground. Claude Lorrain. Sketches are essentially impressionistic. Focus on the principal subject. Method of perceiving 'in order'. Mountain foregrounds. Preliminary sketch. Choice of technique governed largely by time that can be employed. Analysis of special seduction of subject.

CHAPTER IV. VALUES 37
Definition of term. Measuring relative intensity. Simplicity of general value scheme. Corot. Range of palette values. Black mirror. Tricks for perceiving values.

CHAPTER V. LIGHT AND SHADE 42
Light and shade a romantic and emotional element. Usually of a convergent type. Contrast between Rembrandt and Puvis de Chavannes. Light and shade and design. Danger of value error in shadow areas. Monet and Cézanne contrasted. Different classes of light and shade. Exercises in evening silhouette studies.

CHAPTER VI. NATURE OF COLOUR HARMONIES . 47
Impossibility of isolating a tint. Relation between tints. Rough classification of colour conventions. Tints provocative of 'shock'. Shadow tints. Use of pure colour in rendering grey effects. Luminosity ratios. Invariable colour convention. Some palettes. All-importance of relation between shadow tint and light tint. Infant vision. It is destroyed by 'practical' habit. Table of complementaries and values. Impurity of tint in artists' colours. Colour idea. Rhythmic colour.

CHAPTER VII. SIMPLIFICATION 62
Simplification and choice identical. Drawing and values. Geometrical and rhythmical simplification of form. Simplification by : (a) differentiation of value groups ; (b) unification of all values. Values in frontispiece. Study of value grouping in pictures. Subordination of detail to fundamental idea. Recognition of objects represented not necessary. Harmonies and decorative balance are the aims.

PAGE

CHAPTER VIII. COLOUR-BOX AND COLOUR-MIXING 69
Suggested list of tints. Large number unnecessary. Brilliance and purity recommended. Use of white. Study of properties of various colours. Mixing of compound tints. Suggested mixing of two tints.

CHAPTER IX. TECHNICAL HINTS 77
Advice concerning paper. Tinted papers. Glazed papers. Combined use of line and tint. Ink line and colour. Use of pencil. Egyptian, Greek, and Chinese methods of drawing. Putting on of washes. Corrections. Intrinsic qualities of water-colour. First and second washes. Good brushes. List of instruments.

CHAPTER X. CONCERNING THE REPRODUCTIONS 91
Boscastle. J. M. W. Turner ; first pencil sketch and final engraving compared. Pen-and-wash drawing by Rembrandt. Draughtsmanship in water reflections. Treatment of trees and distance. A sketch by Corot. Qualities and defects of Corot's art. Value distribution. A late Venetian sketch by Turner. Seeming simplicity. A painting by Renoir. Accuracy of observation, looseness of brushwork. A drawing by Paul Cézanne. Modelling paramount. A sketch by Claude Lorrain. Accents, tree drawing, modelling. Japanese technique. Analogies with modern art. Emotion and sketching.

CHAPTER XI. THE TREND OF MODERN PAINT-ING 109

INDEX 118

LIST OF PLATES

Château d'Œx. Vernon Blake *Frontispiece*

Boscastle. J. M. W. Turner. By the courtesy of the
Connoisseur *Facing page* 2

A pen-and-wash drawing by Rembrandt. Duke of
Devonshire's collection 16

A sketch by Corot. From *Cézanne und seine Ahnen.*
R. Piper & Co., München 28

Late Turner sketch of the Grand Canal and Dogana,
Venice. By the courtesy of the *Connoisseur* . 36

Example of Impressionism. Renoir, 1875. Photo-
graph: Durand-Ruel 44

A sketch by Paul Cézanne. By the courtesy of Sir
Michael Sadler 45

A sketch by Claude Lorrain. British Museum . 90

A Japanese painting by Sesshū (1420-1506). From
Masterpieces selected from the Fine Arts of the East 106

THE WAY TO SKETCH

INTRODUCTION

ALL those who delight in the changing aspects of nature find themselves animated, sooner or later, by that inspiring desire of the artist to attempt some fixing of her fugitive beauty, some expression of her menace or of her charm, an expression that at the same time, and in an occult way, shall be an expression of his own personality, his own philosophic outlook upon the universe. But painting demands more than an abstract effort of thought, demands more than pure appreciation of beauty, more even than imagination; it is a veritable craft which necessitates the use of special tools, of which the handling must perforce be acquired; we must be possessed of certain technical knowledge before we can practise it. Many are the means by which we may arrive at projecting, on a flat surface, a simulacrum of natural objects : we may simply draw with pen or pencil, we may etch, or lithograph, or even cut on wood ; we may draw or paint in pastel ; we may paint in oil, in tempera, or in water-colour; but all things considered, it is perhaps this last medium which is best adapted to the noting of landscape effects of fleeting colour and light.

I have chosen for the frontispiece one of the most summary sketches of effect that came to my hand. My reasons for so doing are several. First, it is always easier to see how a rapid sketch was executed than it is to guess the overlaid processes by which more finished work is produced;

though at the same time that we see the actual technical method used by the artist, it is not by any means so easy to follow the mental acts of analysis, of synthesis, and of choice that dictated the use and nature of the various lines, dots, and washes that, combined, go to make up a certain arrangement on paper which gives us the impression of a landscape and of a particular effect of light. It is, indeed, a rapid examination of these mental acts which forms the matter of the following pages. Again, the most fascinating form of sketching is undoubtedly that which strives to record a memory of an unusual, of a fleeting effect, which by its very transience demands the use of a swift and simple technique. For this reason it is important that the artist should know how little is really necessary to preserve an impression, provided always that that little be properly chosen. Probably no landscape sketcher has ever so thoroughly, so perfectly estimated the relative importance of the several factors of an impression as Turner did ; and much time may be spent with profit among his most rapid sketches (which sometimes only consist of four or five lines) in studying the exactness of his choice. Lastly, as the title implies, the aim of this book is a study of the essentials of sketching and not of those of finished painting in watercolours ; though, of course, it may be argued that ultimately the essentials of one are the same as those of the other ; still in executing finished work there are many ' added truths ' with whose presence we may dispense in less ambitious work.

The vaguely suggestive flowing of water-colour—as well as the more portable nature of the apparatus it demands—renders this medium particularly appropriate to the amateur's needs. Against its advantages may be brought the disadvantage of requiring a certain amount of skill

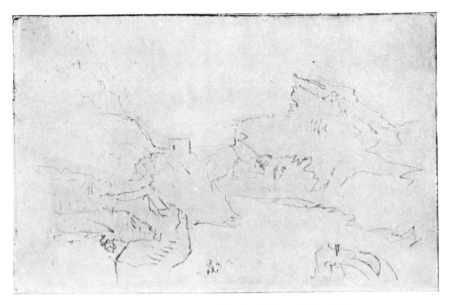

Turner's First Sketch for Finished Water Colour below

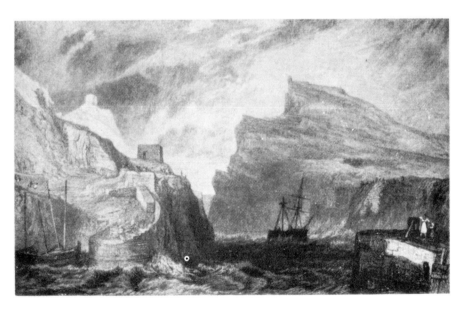

BOSCASTLE. J. M. W. TURNER

By the courtesy of the *Connoisseur*

For the analysis see p. 91

in managing its rather determined refusal to stay exactly where it is put, and to go on creating ' accidents ' on its own account long after the brush has left the paper. However, the accidents thus created are generally of a happy and decorative kind; the skill required to utilize them, as successful adjuncts to the effectiveness of a sketch, is more easily acquired than is the more complete knowledge necessary to the satisfactory execution of work in oil paint. I do not think I am in error in advising the sketcher to rely as much as possible on the vagueness, and on what the French call *enveloppement*,[1] so easily obtainable in watercolour. Were a student determined to go through seriously with the subject of painting, I should still more strongly counsel him to give a wide berth to such adventitious aid; and to be content to wait until sheer quantity of knowledge allow him to control a result which would be the exact expression of his idea.[2] But the way to this end is long; and were the amateur to follow it he would cease *ipso facto* to be one. On the other hand, if the beginner try to detail, or thoroughly control his work, one or both of two things will certainly happen; breadth will disappear in painful elaboration which does not repose on a sufficient basis, and which is as a result unconvincing ; secondly, the colour will probably be dirtied and rendered opaque by being overworked. Strive then to indicate as well as you can the main masses and movements of form and colour, leaving the rest to the care of the envelopment, compara-

[1] The exact value of the technical French painter's word *enveloppement* is rather difficult to explain. It is used as the opposite of sharply defined and limited form whether bounded or not by a contour. In enveloped work the planes which form the sides of an object usually pass by imperceptible gradations into the tints and tones of the background, and even the modelling of the front surface of the object is vague and undecided in its limits. Objects are thus surrounded or enveloped by an undecided zone. [2] See also p. 93.

tively easy to obtain if we work with colour and paper wet enough.

This is why I have chosen for the frontispiece the vaguest of sketches, rather than a more ambitious and completed work which would demonstrate less clearly what is absolutely essential to the subject.

.

Time after time have amateur sketchers confided to me how much even their small technical successes have aided them in understanding and appreciating pictures. Nothing is more evocative of admiration than to see the way in which a master has overcome the difficulty that floored us ; while the general public does not even realize that the difficulty exists. Thus even our failures in sketching bear some fruit, find their reward, or rather their compensation.

Some, impatient of progress, may think that I have accorded too large a space to what they may look on as unnecessary discussion of such subjects as light and shade, values, or perspective; they may be inclined to read the chapter on colour-mixing attentively and hurry over or leave unread the other and seemingly more ' theoretical ' ones. As a matter of fact, the real worth of whatever information on the subject I may be able to impart should be inversely estimated. For instance, get a light-and-shade conception, *thoroughly understand* its gradations, values, and arrangement ; then paint it with the dirtiest mud that an ignorant use of a colour-box can produce; your result will be a work of art, and if your values are correct, your colour will no longer appear dirty. In art the mistake is hardly ever where it seems to be, it is almost always somewhere else. If the relief of your figure seem insufficient, model your background better; if your sunlight lack brilliance, see to the colour and value of your shadows;

it is they that are wrong. If a chapter in this book appear superfluous, read it with redoubled attention. The artistic quality is produced by the reaction of one element on another, and the apparent success or non-success of the obvious points is always due to the way in which they are upheld by those to which our interest is not attracted. We all of us know the reply attributed to Van Dyck to the statement made by the person who presented a would-be apprentice to him, namely : ' He already knows how to paint a background.' ' Does he ? ' replied Van Dyck, ' then he knows more than I do ! '

No subject, when studied, tends so much as art to shake the faith in human judgement or rather in the judgement of that good or common sense which Descartes in the opening lines of the *Discours sur la Méthode* announces, not without a hint of Socratic irony, to be the most equally apportioned thing. ' Le bon sens ', says he, ' est la chose du monde la mieux partagée, car chacun pense en être si bien pourvu, que ceux même qui sont les plus difficiles à contenter en toute autre chose n'ont point coutume d'en désirer plus qu'ils en ont.' [1] In the pursuit of art we learn that the aspect of things is transient, and that its effect on our personality continually differs ; that never twice do we see or estimate a subject at the same value ; that a change of lighting will make or destroy the artistic worth of a scene; that never may we reproduce a sketch exactly. Moreover, we learn, as I have just said, that the chief importance does not lie in the object itself, which is the common-sense view of the matter, but in certain delicate and complex relations established between the object and its ambience ; and only the study of these relations will enable us to reproduce in

[1] ' Good sense is the best-distributed thing in the world, for every one thinks that he is so well provided with it, that even those least easy to satisfy in all other matters do not usually wish for more than they possess of it.'

paint the image of the object. The fundamental note sounded throughout the following pages is: Swear by and study the relations of things. When you understand just how the appearance of sunlight is related to the appearance of shadow, you will know how to paint a luminous sunlit picture. Painting is little more than seeing relations correctly ; at least the executive side of it is no more; to what extent this perception of relations at their true worth may or may not constitute the whole art leads to a discussion that would more properly find place in a work on theoretical aesthetics.

The beginner will probably not go far wrong in following two rules : that what he is inclined to think unimportant is really the most important; and that what he thinks wrong in his sketch is probably the rightest part of it, and that everything else should be corrected. The number of times that the following of such rules will induce error is so small as to be negligible, paradoxical though they seem to be.

If you have a taste for decorating your house with maxims, I should recommend the use of a phrase that appears in Michael Angelo's own handwriting on a sheet of his drawings now in the British Museum. It is (I quote from memory) 'Disegna sempre, e non perder tempo';[1] for drawing is the only satisfactory basis to pictorial reproduction.

[1] 'Always be drawing, and do not waste time.'

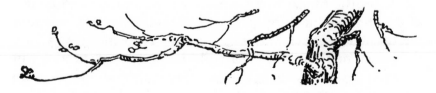

I

PERSPECTIVE

IF we wish to express on a flat surface the appearance of natural objects, we are obliged to make some use of that branch of scientific study known as perspective. A knowledge of perspective is not absolutely necessary for pictorial representation, though it is for all pictorial representation which aims at illusion and not at mere schematic and decorative presentation of ideas. However, the deliberate study of perspective only dates from the latter years of the Italian renaissance; and all Greek and Roman painting, though containing of necessity certain essentials of perspective, was innocent of the accurate application of its theory.

Landscape painting is of comparatively recent development in the world's history, and only, indeed, became possible after a fairly accurate understanding of perspective had been achieved, on account of the greater depths of distance which almost inevitably occur in that form of painting.

It is true that Chinese landscape work sometimes applies, and sometimes voluntarily ignores, the elementary rules of perspective; but Chinese art stands in a peculiar equilibrium between natural representation and decorative considerations, and as such falls without our self-imposed limits.

An abstruse study of the many and complicated geometrical constructions for solving the innumerable problems that may occur is quite unnecessary for us; but

nevertheless we must take into consideration a few of the more simple and elementary facts connected with perspective which we must on no account violate, unless we are prepared to pay the penalty of seeming error in our work, and of failure in efficiency of illusion.

.

When you look out over the sea, or over a level plain, you see it bounded by the horizon; this horizon always appears to be on a level with the eye; if you hold your pencil out at arm's length, and horizontally at the height of your eye, you will see that the horizon appears to coincide with it. Whenever you sit down to make a sketch you have a horizon in front of you; you may not be able to see it, on account of intervening hills or trees or houses, but you must always make up your mind just where, could you see it, it would cut across your 'subject'. That is of course quite easily done by holding up your pencil, as I have just said. In the accompanying diagram (Fig. 1) the horizon is figured by the dotted line HH. You should always avoid placing the horizon just half-way up the picture; the result is never pleasing. The importance of the Horizon Line is this:

(1) On it lies a point called the Point of Sight; it is exactly opposite your eye. To this point converge all lines that are at right angles to the picture plane.

(2) To another point on the horizon all lines at 45° to the picture plane converge. This point is called the Distance Point; its distance from the point of sight is the same as that from the Station Point of the observer to the picture plane. To obtain a normal and comfortable perspective effect, this distance should not be too small.

(3) Horizontal lines which are parallel to them-
selves, but are neither parallel to the picture plane,
nor at right angles to it, converge towards special
Vanishing Points of their own. These vanishing
points also are on the horizon line.

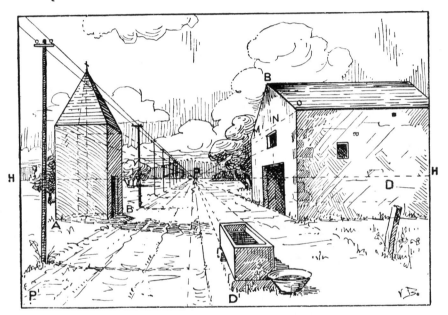

FIG. 1. Shows how parallel lines at right angles to the plane of the picture 'vanish'
to the Point of Sight, P, which is situated on the Horizon Line exactly opposite the
artist's eye. In this case the artist would be standing on the right-hand side of the
road some distance from the picture plane. This distance (in the scale of the picture)
may be found by producing the diagonal AB (which is at 45° with the picture plane)
till it cuts the Horizon Line at D. The artist is standing at the distance PD from
the picture plane; or in other words the foreground begins some, say, 5 yds. from his
feet; P'D' (equal to PD) seeming to be about 5 yds. long. D is called the Distance Point.

At the same time, vertical parallel lines remain parallel
in your sketch.

Distance and vanishing points may lie, generally do lie,
outside the limits of your sketch on an imaginary pro-
longation of the horizon line.

Of course you must always make the side of a house, seen obliquely, shorter than it would be if looked at from straight in front; just how much shorter we cannot say without going too deeply into mathematical perspective; also remember that its middle point will appear a little farther off than half-way in your drawing. This is very useful in making roofs look right. In the sketch (Fig. 1) MN is a little shorter than NO, so R is a little farther into the picture, and consequently RM slopes a little more than RO.

Circles in perspective become true ovals,[1] unless they are seen edge on, and exactly opposite the eye; when they naturally become straight lines. Thus in the circular tower (Fig. 2) AB is curved ovalwise a little upwards; CE is straight, and above CE the lines are curved more and more downwards. The circle may always be supposed to be inscribed in a square, which is thrown into perspective by the usual rules as in the figure.

In drawing arches and similar things, draw the imaginary lines XY and OZ in perspective; then on XY make your half-oval, but make it lean a little towards Y. But a study of the accompanying sketches will do more than any amount of verbal description. It should be remembered that cloud forms also obey perspective laws (G, Fig. 2).

Beginners generally find great difficulty in placing the sloping roof of a square tower correctly; its top point is vertically over the perspective centre of its base. In Fig. 3 I have represented three different forms of roof in perspective; as well as the use of two vanishing points, P and P', which are necessary in the case of rectangular objects placed obliquely in the picture. It will also be noticed that, here, both the vanishing points fall outside the picture. In

[1] Except when the vertical through the Station Point, where the spectator is standing, falls either on the circumference or within it. In the first case the perspective curve is a parabola; in the second a hyperbola.

practice one nearly always does; and both generally do,
or at least very often.

Naturally in making a sketch one does not go through

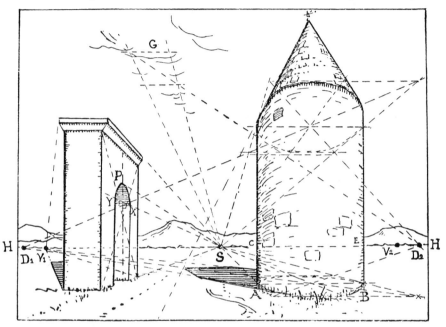

FIG. 2. Shows certain other perspective facts. The superimposed circles on the
right are supposed to be traced in imaginary squares, the sides of which 'vanish'
to the Point of Sight, s. The circles become ovals; except at CE, where the circle
becomes a straight line. The curve on YX is slightly 'tilted' from the Point of
Sight; its highest point, P, is not vertically over the middle point of YX, but a little
'nearer'. It should not be forgotten that cloud forms also obey perspective laws.
See G. For the method of tracing cast shadows the reader is referred to *The Art and
Craft of Drawing.*

even these simple constructions; one only thinks of them
and draws in such a way as not to violate the laws to too
great an extent.

You must remember that perspective applies just as much
when the objects have no distinct geometrical form as when
they have one. You can easily imagine straight lines on

their surfaces to help you. Trees on level ground must come out of the ground at points which lie on the perspective plane (Fig. 4).

By holding up your pencil at arm's length, and either vertically or horizontally, it is very easy to roughly estimate

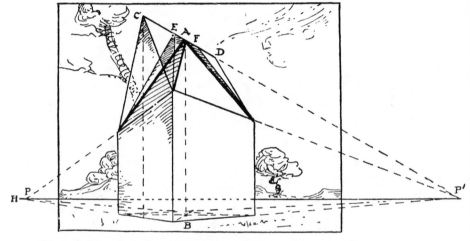

FIG. 3. Shows how three types of roof may be drawn in perspective. The sides of the house ' vanish ' respectively to the two vanishing points, P and P'. CD also vanishes to P'. The middle point B is found by drawing the perspective diagonals of the ground-plan. The point A must be vertically over B; just as it really is over the real central point of the house. It is to be noted that CA is longer than AD. It may also be noted that although P and P' are outside the picture, they are still too near to give an agreeable perspective effect; the perspective is still too ' steep '.

the angle that the line of a roof or the edge of a road appears to make with it; it is then quite easy to reproduce this angle in your sketch.

The observance of these few rules will be quite enough to allow you to make drawings in sufficiently good perspective for your purpose; especially as you will always have nature before your eyes only waiting to be copied.

Perspective, when treated at all fully, becomes really

quite a difficult subject, and demands considerable mathematical knowledge; so we can only afford just to glance at its most important points. Special treatises on the subject are not rare, and may be consulted by those who wish to complete their knowledge of the subject.[1] By means of

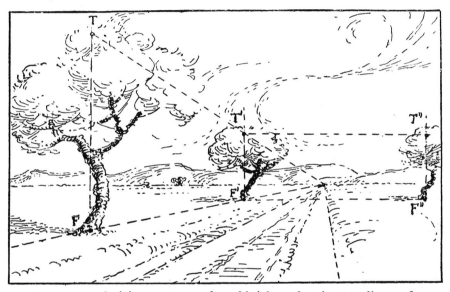

FIG. 4. TF and T′F′ are two trees of equal height, and at the same distance from the edge of the road. T″F″ is a third tree of again the same height, but farther from the road, though at the same distance as T′F′ from the artist. Note the perspective facts that it is necessary to observe.

perspective the shapes of cast shadows can be accurately determined; but as you will always be drawing from nature, you will only have to draw them carefully as you see them. This is a very important point, which most amateurs overlook; the shadow is to the naturalistic painter more important perhaps than the object. If you

[1] For example: *The Theory and Practice of Perspective.* By G. A. Storey, A.R.A. Clarendon Press, Oxford.

do not believe it, look at Fig. 5, in which the shadows only are indicated.

FIG. 5. Shows how a careful study of shadow shapes is really all that is necessary very often to suggest the existence of objects. One of the most usual defects of drawings is carelessness in shadow drawing; especially in foregrounds. A few careless washes are supposed to be all that is necessary to represent the shadow of a tree on the road. On the contrary, perhaps in no other place does careful drawing 'tell' so much. You can create the modelling of the foreground by accurate drawing of the shadows that lie upon it.

Another point to be noticed about cast shadows is that, as they take the form of parallel strips on the ground, they must be made to converge towards a vanishing point;

except of course when they are exactly parallel to the plane
of the picture.

.

The question of reflections in still water may be studied
theoretically; but as a rule the sketcher from nature may
depend on the observations that he can make while at work
on his subject. Let him only remember that here as else-
where he must look at his model; make a selection of the
phenomena that he sees; and reproduce them. The only
real way to render water pictorially is faithfully to re-
produce its appearance, which each time is different; all
tricks are to be severely condemned. In practice it is very
rare to meet with absolutely still water giving theoretically
simple reflections; but should we do so we may remark
that all objects rising from the surface or edge of the water
are exactly reproduced upside down, and that perspective
lines of the reflections converge to the same vanishing points
as those of the object itself. If, however, the object reflected
be placed at some distance inland, only the upper part of
the object will be reflected, and then only if it be high
enough. The reason for this is easily seen from Fig. 6 when
we remember that the angle of incidence is equal to the
angle of reflection ; B is the edge of the water surface BH,
and is consequently the last point capable of reflecting. If
AD be a vertical object, we may find whether it will be
reflected or not by joining the eye E to B; then making an
angle FBG equal to the angle EBC (these two angles are re-
spectively the complements of the angles of reflection and
incidence), by which we find that G is the point reflected
at B, but as G is above the object AD, the latter will not be
reflected at all. The object must be higher than G in order
to be reflected; even then only the upper part of it will
appear in the reflection. Thus the part MK of MI will be

reflected and will seem to stand reversed in the prolongation of EC and EB. It is hardly necessary to point out that it is the under-side of objects that is reflected; that is, what would be seen of them if the eye were placed at B (Fig. 6) at the surface of the water.

As soon as the surface is rippled, and this is nearly always the case, the reflections take place from the sloping

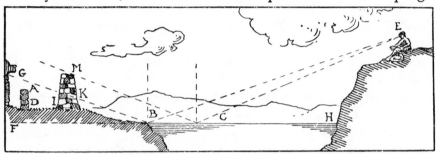

FIG. 6. Shows how an object AD may not be reflected at all from the surface BC of the water; or how only the top part MK of MI will be seen in reflection. The angle MCF is equal to the angle ECH; and the angle GBF is equal to the angle EBC. They are in each case the complements of the angles of incidence and of reflection. The under-side of an object placed at G is reflected just as if the eye saw it from the point B.

surfaces of innumerable little waves, with the result that the image is blurred, confused, and brought forward along the surface towards the observer; thus giving the effect of long indistinct vertical draggings, of various colour and value, sometimes crossed by lines of light that are either straight or are perspective views of curves on the surface. These are caused by relatively still parts of the surface which, instead of reflecting the same objects as the ripples, reflect the sky. It should be noticed that all reflections are darker than the objects reflected, on account of the loss of the part of the light that penetrates the surface of the water.

While writing on the subject of reflections the memory of a certain canvas I once painted of the bridge at Riéka in

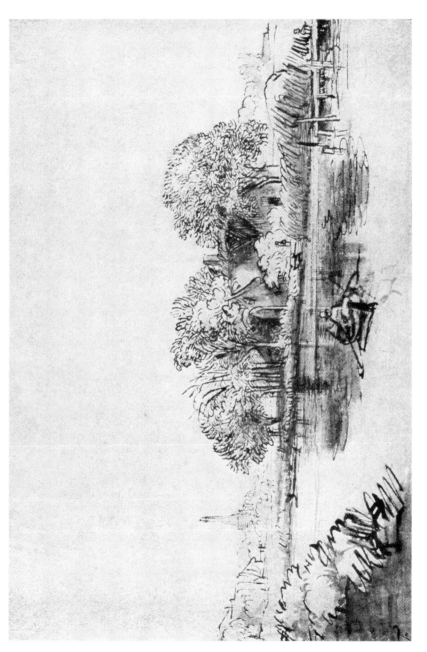

A PEN-AND-WASH DRAWING BY REMBRANDT

Duke of Devonshire's collection

For analysis see p. 92

Montenegro comes back to me. The subject of the picture
was more truly the delicate differences of colour and value
inborn of the crossing of the shadow of the bridge and its
reflection in the transparent water. I was close to the end
of the bridge. The bridge was high and narrow, and ran
back into the picture in rapid perspective. I took con-
siderable trouble with my drawing. Although the canvas
was not a large one, I made a pencil study in my sketch-
book, and then squared the drawing out on the canvas.
Nevertheless, when my drawing was done the bridge ap-
peared laterally convex in form instead of crossing the river
in a straight line. Evidently there was an error in the per-
spective; I established a few perspective lines and found
that all the nearer part of the bridge was, as I had supposed,
incorrectly drawn. I corrected according to theory, but
found to my further astonishment that I had no longer
room enough under the first arch to place all the landscape
that I could see through it in nature. It was then that the
explanation of the error dawned on me: unconsciously,
and without changing my place, I had looked in at least
two different directions while making my drawing; and,
as a consequence, I had at least two different principal
vanishing points in my picture, whence two separate per-
spective systems. I ultimately arranged matters sufficiently
well by splitting the difference between the first idea and
the results of theory. The trouble arose from my fore-
ground having been taken too close to me. I was obliged
to turn my head in order to see all of it.

Much may be learnt by drawing on a window pane the
appearance of the houses and other objects seen through it.
We must remain in exactly the same place while executing
the drawing; otherwise the distance point, and in con-
sequence all the perspective, will be changed.

II

ON LANDSCAPE DRAWING

ALL form is governed by the physical laws of the universe. The shape of a mountain is the result of the action of gravity and the cohesion of the different rocks that compose it. The shape of a tree or a plant is again the result of the laws of organic growth, combined with those of gravitation. In our drawings we must indicate the existence of such laws; that is to say, we must pay special attention to the parts which particularly indicate their influence, and even, owing to the reduced scale of our work, caricature and exaggerate such indications. It is the seizing on these facts which gives life and naturalness to drawing.

Unquestionably the best way to study these productive laws of form is to acquire that intimate acquaintance with the human body that long years of nude drawing alone can give. The variations of surface form in animals is obscured by fur; the shapes of trees and plants are too various to allow of that sufficiently absolute criticism of the result which is of great importance in exercise work done with a view to learning. On the human form the changing action of gravity, as the pose differs, produces curiously delicate modifications in all directions; and the prolonged study of them renders the eye excessively sensitive to the nature of form.

But we are not considering here those among us who are prepared to take up such serious work, so we must try to arrive at a good enough result by a shorter cut.

Let us first consider the shapes that the earth itself

presents to us, before going on to those of things which
grow upon it.

The rounded form of a down is not an arbitrary curve,
but is modelled by many forces, the chief of which, as we
have said, is gravitation. Remember this at every moment
in your drawing; feel, so to speak, your pencil pulled
downwards all the time that it traces the curve of the sky-
line. It is thus that you may register some of the feeling
of weight or immense stability of the mass before you.
You should also learn to look on a profile not as a line, but
as the limit of a solid volume; and your pencil point
should seem to you, not to be running over the surface
of your paper, but to perform somewhat the office of a
knife cutting shape out of a solid mass of modelling clay.
Keep yourself continually remembering, while drawing
the profile, that the point A (Fig. 7) is so much in front of
the point B, and that there is a point C, just *so* far over the
brow of the hill, although you can't see it. Such mind
efforts, if industriously carried out, always imprint their
nature in the work. We must also remember that natural
form is always rhythmic; sometimes the rhythm is com-
plicated, sometimes simple. In any case we must, so to say,
soak ourselves in the particular rhythm before trying to
reproduce it.

Sometimes we have before us a regularly rhythmic land-
scape, in which the gently curved line seems to undulate
at approximately the same rate from one end to the other.
Elsewhere the rhythm may be of an interrupted nature;
it may mount with a nervous springing sweep; then pause,
perhaps drop vertically downwards, before continuing to
fall along a slower and more even curve. It is like a series
of musical notes, now grouped in quick succession; now
halting; now moving onward with a stately regularity.

The pencil of a sure and skilful draughtsman will actually perform these differences of speed, at times divided by

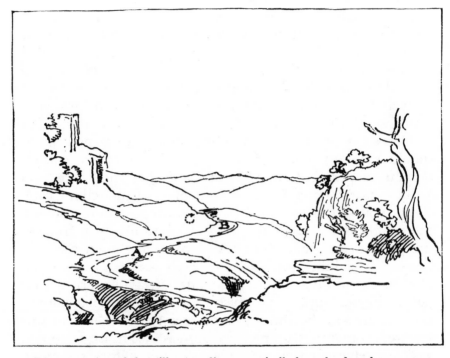

Fig. 7. Is intended to illustrate diagrammatically how the draughtsman mu.st ' think ' of the modelling, of all the shape of the interior form, of its to-and-fro movements, to and from him, while he is drawing the simple profile. In other words, he must be sure just how such a line as ABC would lie along the surface. He must remember all the time that such a point as c exists although it is hidden from him by the intervening mass of the hill itself. All the points of the picture must be deliberately placed ' into ' the picture and not ' on ' the paper. The artist must be himself a victim of the illusion he is producing.

stops, in transcribing the shape; a line is, in this way, exactly similar to a piece of music. In the high mountains we generally meet with still more broken form; but it is always governed by a rhythm of some kind, and always

has a tendency to gradually decrease in precipitousness as we decline towards the plain; for the foot of a mountain is always buried under the detritus fallen from the higher parts.

When you can see the exact shape taken up by such detritus under the action of gravity, you can draw it; for drawing is nothing but seeing. When we can see exactly, and estimate the *relative importance* of the component parts of what we see, then we can draw. Do not fall into the elementary error of trying to make mountains appear more imposing by rendering them more pointed, or by exaggerating their jaggedness; you will only succeed in making them look as if they were cut out of cardboard. What makes a mountain imposing is the immense feeling of mass and stability that it gives us; and this is best rendered by increasing, rather than by diminishing, the width of its base.

Remember that all sedimentary rocks are composed of strata, generally more or less horizontal, and that this fact *must be rendered* in the drawing, either openly or by implication.

It is very tempting to draw the vertical profile of some rounded forms of sedimentary rock as a simple line. This is generally dangerous, being apt to produce an unconvincing impression of flat scenic rocks, such as one sees on the stage.

In some way one must indicate the superposition of the different strata; we must give an explanation of the forms, by here and there actually drawing the stratification lines on the face of the rock turned towards the spectator, and by insisting on the entering parts of the profile. It is of course possible to draw the profile with a single line, but the draughtsman must govern the movements of his pencil

in such a way as to suggest the existence of the stratification. It is useless to draw a mountain form without having a clear idea as to whether it is composed of unstratified igneous rock, or of stratified sedimentary rock; and in the latter case we must determine the direction of the stratification. All these observations are very easy to make and require no long nor special study.

Turning now to the consideration of tree and plant form: we see at once that while the shape of a mountain is due to continued destruction, that of living things is due to continued construction; so it is not extraordinary that great differences should exist between the two. A tree is an entity in a way that a mountain is not; no one can say just where a mountain finishes, and this fact of unity with the rest of the earth must show in our drawing. The important fact about a mountain is the stable way in which it is joined to the earth; that about a tree is the way in which it grows *out of* the earth. A tree is not in stable equilibrium, it is top-heavy. It is only kept up by strength of material; it is a system in which strength of material and vital force continually defy gravitation, which is almost the supreme lord of the mountain. There is a sense of upward movement about all plant and tree form which may be specially noticed where the trunk or stem comes out of the ground; but if the ground is sloping, the first movement may be one perpendicular to the surface. At any rate, think of this movement and feel it while you are drawing. Combined with this there is a certain fountain-like radiation in the vegetable world, in which, however, all the directions are co-ordinated and fall into a pre-established rhythm.

Do not scribble in branches anyhow, make careful choice of a few, and draw them accurately; a bare half-dozen are

often sufficient for a sketch. Notice carefully the way in which branches come out of one another and out of the main trunk; there is often a swelling, which seems to solder the one to the other. Also remember that not many of the branches will come exactly sideways out of the trunk—that is, in a plane at right angles to the line from your eye—but that most of the branches come towards you or are directed away from you. You should carefully indicate, by drawing the forms at the junction, just in what direction the branch comes out of the trunk. More or less foreshortened branches are always a stumbling-block to the inexperienced artist; they must be drawn carefully, looking on them as a series of cylinders, seen more or less end on, and in perspective. Tree trunks and branches are not conical, they are cylindrical, and are reduced suddenly after each fork, the sectional area below the fork corresponding to a certain extent to the sum of the sections above it. Indicate the way in which the trunk comes towards you or goes away from you. Only one thing can save us from cotton-woolly trees, and that is good drawing of the masses of the leaves; as a rule beginners do not look enough at the model, they try to make the drawing ' look right '. If they would only look at what they are supposed to be copying, they would always find more than enough material to use in the production of a good drawing. Force yourself to see objects in an uncompromising simplicity of two factors: a light side and a shadow side; and *draw exactly* the boundary between the two. Very little is wanted to modify such treatment to a sufficient degree of envelopment, by occasional passages of half-tone, copied from nature, between light and shadow.

Every tree has its characteristic form; one is erect and springing; another stocky and with winding, twisting

branches. In some trees, like the weeping willow and the palm, simple curved forms, created by the weight of branches, themselves too slender to resist the strain, are in predominance. Each tree in your drawing should belong to a recognizable species; one should be able to name it from your work; any attempt to substitute a 'type' tree executed from a formula will be a failure. I will not say that every careful pencil drawing of a tree or a plant from nature is worth, instructively, a hundred vague water-colours; but I will say that every one that you have the courage to make will teach you a quantity of facts that you will never learn otherwise.

Plants, from their diminutive size, play a much more limited role in the sketch, which is usually of small dimensions, except in so much as they make up masses in the foreground. Perhaps all that is necessary to be said here about them will find better place in the chapter on simplification.

We might establish one or two maxims concerning drawing. First: Look long at what you are going to draw, and thoroughly understand at least two things about it—the proportions of the component parts, both internally to themselves and relatively to the whole subject; and then the *main* directions of its different parts to and from you as well as sideways. You should always understand the arrangement of your subject so completely as to be able to make a map or ground-plan of it if you were asked to do so. If every one did this, we should often be saved the flat, paper hills, that should be in the distance, but insist on crowning the foreground. Secondly : Make up your mind fully about what you are going to do with a line before beginning to draw it; then draw it with unhesitating determination. Do *all* the hesitating before you begin. Think a line out

before executing it; choose just what details of nature it shall represent; its length, direction, and kind of curvature. Mark points on your paper, if necessary, to help your execution. Weakness in drawing is largely lack of decided and completed intention before commencing. Thirdly : Study the particular rhythm of each form and try your best to reproduce it. Remember that a painting is but a rhythmic arrangement of form and colour, so our every effort must be towards the maintenance of the unity of rhythm.

Is it necessary to speak of the rough-and-ready means of comparing two distances by holding one's pencil out at arm's length, closing one eye, and while making one end of the pencil appear to coincide with one point, sliding the thumb along the pencil till it seems just in front of the other limit? The length measured on the pencil can then be transferred, still at arm's length, to another part of the subject, and the comparison instituted.

III

CHOICE OF SUBJECT AND COMPOSITION

A GOOD choice of subject is possibly the most difficult part of landscape work, and one feels that it is perhaps the most delicate to write about; for obviously the choice and arrangement may be varied to an almost infinite degree. Nevertheless, most inexperienced artists sin in certain fixed ways; which ways I will try my best to point out. It must not be supposed that these few counsels exhaust even the beginnings of the matter; they are only addressed to those who wish to conserve agreeable souvenirs, and not to artists who desire to arrive at personal expression by means of plastic arrangement.

The first error that most beginners make is to deliberately sit down in front of the object of their admiration and draw it all. Now nine times out of ten you will get a much better picture out of your Roman arch, or your picturesque bridge, if you throw it back into at least the second plane of your picture, even letting it be half concealed behind a group of trees. It is curious how small you can make the principal object in a picture, without causing it to lose in importance, provided you lead the eye up to it properly. Not only does the object not lose in importance by pursuing this method, but it often gains; the reason being twofold: that more elements of comparison are brought into comfortable touch with it; and that the eye feels instinctively its importance, because the main lines of the picture lead up to it from everywhere.

You should always be very careful to distinguish between

things which are only interesting from the point of view of association of ideas and those which really offer some pictorial interest. It is just as well to leave the first severely alone. Also avoid whole mountain valleys with a lake, some rivers, woods, fields, a complicated light effect, and a glacier or two. With thirty years of experience and no inconsiderable amount of genius Turner managed to do something with such subjects. As for ordinary mortals, the task is rather hopeless, and you will do best to cultivate a certain mastery of your means by attacking the very simplest subjects you can find to begin with; just as Turner himself did, by the by.

When drawing you should forget the drawing as much as possible, and study the object, the aspect of which you are trying to reproduce. You should not try to learn ' how to do a tree '; but you should seize on observed facts and reproduce them almost naively. On the other hand, composition is a more artificial thing; though, of course, the foundation of a good arrangement exists in nature. Even when we have found a good subject, a yard or two to the right or to the left will change the point of view from a good to a bad one. We must then keep in front of us the idea of this picture, that is, give the idea of our reproduction precedence over the idea of nature. We must even modify the composition before our eyes; either much, if we are clever enough, as did Turner; or little, if we are not masters of the art of arrangement.

Nature, one may say, is made to be looked at from all points of view and without a frame; so she has no need of pictorial composition. The painter has only one point of view and a very limited space to deal with. That is why he calls in the aid of decorative arrangement. Even the most conscientious impressionist, who loudly declares that

he alters nothing, and cuts a bit straight out of nature as it is, really does modify what he sees. He insists on certain things which find place in the more important parts of his canvas; and leaves hardly indicated some part of, say, the foreground, that, if it were fully elaborated, would distract the spectator's attention and prevent him from seeing the work of art as a whole. Even in the work of the most revolutionary modern painters we can unearth the same eternal laws of pictorial arrangement that they fain would banish, and do so—in words. As soon as the eye becomes used to certain superficial novelties of cubism, futurism, and other -isms, we find that they are after all very ordinary affairs fundamentally; and can all be reduced to the same eternal elements of art. But an exact statement of these elements would be of too theoretical a nature to be of much use to us here; I have only spoken of their existence in order to forestall criticism from nature enthusiasts, or others, who may be inclined to find fault with me for laying down a few rules; which, it must be remembered, are in no way general, but are simply destined to help the beginner to produce pleasing results.

Must I say : Do not place your principal point of interest or principal mass in the exact centre of the paper? Probably the easiest kind of composition to manage, and one that presents itself, under one form or another, most often in landscape, is the one which was almost reduced to a system by Corot. It consists of a large mass on one side of the canvas; a smaller one on the other to balance it; and a secondary series of equilibria woven into the primary one, and which are all balanced round a principal point or fulcrum, to which everything tends to lead the eye. In every picture that is to give us satisfaction the eye must be finally led to one point, and to one only. In Fig. 8 this

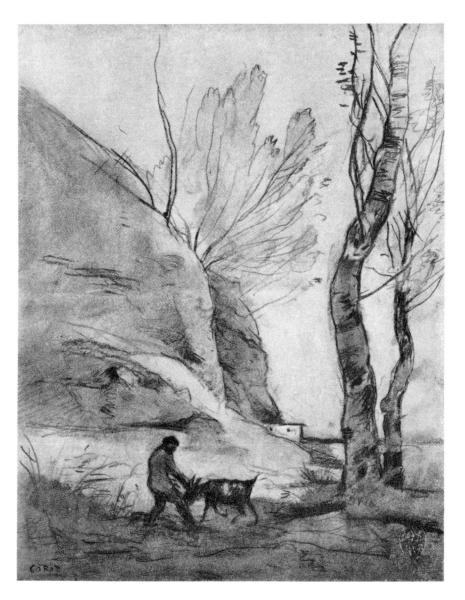

A SKETCH BY COROT

From *Cézanne und seine Ahnen* ; R. Piper and Co., München

For analysis see p. 95

point is at P. The greater mass of the distant mountain B is to the right of P, thus forming an agreeable diversion from the primary arrangement, in which the greater mass

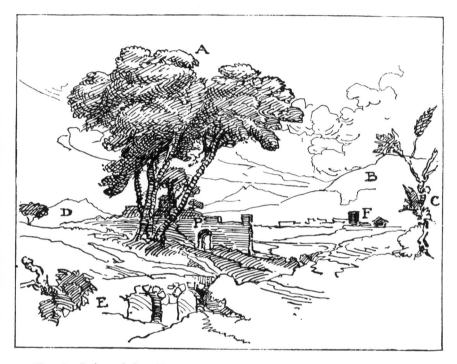

FIG. 8. Is intended to illustrate the building up of a composition in order of importance of essential facts. The main mass is that of the tree group A. The secondary tree group C is placed on the opposite side of the 'fulcrum' point P, round which the composition is balanced. The main mountain mass B is on the opposite side of P from the secondary mountain mass D (thus reversing the tree arrangement). An accent at E calls for another accent at F. And so on.

A is to the left; and C, the smaller, is to the right. Thus is established a secondary equilibrium between the two equilibria of B and D about P, and A and C about the same point. A similar series of balancings must be established through-

out the picture; it is just here that the landscape artist makes *unconscious* choice. He will, for example, indicate some plants at E and will then be led, perhaps later and without knowing quite why he does it, to add an accent, say, at F; thus continuing the back-and-forth weaving of the equilibrium. This is what constitutes a proper choice and arrangement of accents in a picture.

But my reader will perhaps object that I am working out a theory only applicable to landscape composed and executed in the studio. However, a little observation will convince him of the existence of a curious fact, the causes of which, physical, psychological, and metaphysical, we need not discuss. This fact is that when he has chosen a good subject and point of view, and has begun to reproduce the former, every time that his canvas betrays an empty space, either large or small, he has only to look at the corresponding place in the landscape in order to find just the interesting plant or branch that is wanted to fill it up; and which takes just the right direction, and has the right volume. Indeed, the faculty of completing a landscape sketch really amounts to nothing more than a power of judging the relative aesthetic importance of observable facts, and their reproduction in that order; to this the whole of the executive side of art may be reduced. All the training of a serious artist tends towards this end; it is the perfection of judgement of the order of importance, and the subsequent exact choice of the facts expressed, facts chosen just so far along the scale of importance as the degree of finish may require, that constitute the greater part of the value of the summary sketch of a master. Your work will be a success just in so far as you succeed in your estimation of the relative importance of the essentials of the landscape before you.

It would be as well to clearly establish these essentials as a matter of reasoning before beginning your drawing. If you do not see your way to making some kind of rhythmic balance out of these essentials, you will do better to abandon the subject, however enticing may be the picturesque gateway or other object that brought your sketch-book out of your pocket. Why I say this is that nothing is more difficult to do than a badly composed sketch; one wastes much labour on it, and the result is poor. Few sayings are truer than the apparent paradox that it is easier to paint a good picture than it is to paint a bad one. When your idea and composition are good, the picture almost paints itself. Touch after touch suggests itself; nature and the appearance of the growing painting between them seem to vie with one another in providing you with all the ideas. On the other hand, a bad arrangement is mute; one feels all the time that there is something wrong; and one struggles by repeated experiments in accents, in shadows, in rubbings out to correct what will not be corrected because the base is faulty. Most of the failures are due to bad choice of subject, which generally comes from omission on the part of the artist to ask himself: 'Why do I admire that? Is it strictly and only from a plastic point of view?' And then, if the answer be affirmative, to continue with the question, 'Is the foreground a paintable one?'

The foreground of a picture is of very great importance, even if it be treated in the most summary way. It must be of such a nature, and arranged in such a way, that the eye may quickly and easily run over it to the principal parts of the picture. A large part of the immeasurable distances in Turner's sketches is due to masterly treatment of the foreground; he gives you a complete conception of the

extent of the first fifty or a hundred yards, before starting on the real subject-matter of the picture; but he often exaggerates and carries us through complicated groups of people, still life, and variations of ground surface that only his consummate skill is able to manage; even he is not always completely successful at the task. Still, the lesson that we may take away is to carefully consider and model the foreground. By which I do not mean elaborate and detail it, but simply to have and to express a very decided sense of its plastic form. I have known very skilful professional water-colours half spoilt by a complete lack of formal indication in the foreground washes; the artist has been uniquely preoccupied in getting a good arrangement of colour, and clean, smart washes, instead of treating his foreground literally as a solid *fore* ground to be traversed before reaching the rest of the picture. The foreground may be as void of detail as you please, mere enveloped areas of colour and value, if you choose some distant object as definite point of eye focus ; but these areas must pass over and suggest real solid tangible form, none the less really existing because the eye is not focused upon it, but only just notices it in passing. You must have taken the trouble to have seriously considered and understood the topography of your foreground. Sometimes the foreground is water, in which case it is imperative to make a very careful indication of the *extent* of the surface by means of accurate reproduction of observed facts of reflection, wave-form, and so on. Unquestionably a foreground is a difficult thing to manage properly. Most people adopt the simple solution of detailing and putting in dark accents; which, as they say, make it come forward; which it does do usually to the detriment of the rest of the picture. If you feel yourself incapable of doing otherwise, use this

method; but remember that the only true solution of the difficulty lies in the plastic conception of the forms, whether detailed or simplified. Many of Claude Lorrain's sketches reverse the usual method and place strong accents back in the picture. His sketches should be much studied.

We are here dealing with sketching and not with finished picture work. Now all sketching is more or less impressionistic in nature; it aims more at suggestion of things than at categoric representation of them; for the latter, as a rule, the sketcher has not time enough. Not only must he place the most interesting object or objects, those that he means to insist on and elaborate to a certain degree, in a chosen and probably fairly central place in the composition; but he must focus his eye on that place, and see the rest of the subject, both before and behnd that point, more or less out of focus. This will bring with it that sense of conviction which is essential to pictorial art; and which is sometimes attained by this means, sometimes by others quite different, but which may be considered, I believe, to be without our present province; for we are not supposed to venture into the realms of stylization, synthetic treatment, or decorative ideals. You should accustom yourself to fix some object with the eye, and then, without ceasing to regard it fixedly, *perceive* the surrounding objects, taking care not to look directly at them. You will find this of great aid in treating them broadly, and in keeping their execution properly co-ordinated with that of the principal object regarded.

The subject-seeker in mountainous country will often encounter a serious difficulty; namely, that of finding a foreground that does not ' fall out ' of the picture. By which is meant that the main lines of the foreground, on account of its slope to one side or the other, rapidly carry

the eye out of the picture instead of helping it towards the principal object, often a mountain peak on the other side of the valley. No ready-made recipe can be given in this case. With much exercise of skill we may rectify matters by choice of effect. Sometimes the part which insists on falling away may be so enveloped, treated so vaguely, that a corresponding insistence on oppositional facts saves the situation. Sometimes the timely aid of a tree or a rock, which, by moving a little to the right or to the left, we bring into the subject, completes the equilibrium and arrests the eye.

The eye always has a tendency to travel over surfaces and along lines; all our main lines and surfaces must be so inclined to one another as to lead the eye in one direction; otherwise confusion and uncomfortable sensation arises.

It is just as well to make a preliminary sketch on another piece of paper in order to decide on the exact placing of the main masses or objects before beginning the final drawing; this method will often save rubbing out and false starts. This first sketch, of course, is made in as summary a fashion as possible, just a few lines scribbled on the paper; these are, all the same, enough to call attention to many facts of measurement and placing that one would perhaps otherwise notice too late. Another good trick is to cut, in a card or piece of paper, a hole of the same rectangular proportions as the sketch is intended to have, but no larger in actual superficies than about two or three square inches. By holding this card up in front of the landscape, and at a suitable distance from the eye, several different placings of the subject may be tried in this primitive frame.

When you have decided on both the subject and its placing, its technical treatment still remains unfixed; un-

less, indeed, you make every subject fit itself to the same method of reproduction.

In solving this question of treatment we must take several things into consideration. If time be limited, our technique must be of a kind which will permit the noting of the greatest number of facts as quickly as possible. We shall almost certainly choose a mixed method of line, either pen or pencil, and colour; or even, if the time be very limited, we shall suppress the latter altogether.[1] At any rate, after having decided that the charm of a subject is really of a kind which is fitted to plastic reproduction, we must carefully decide on the exact nature of the charm. One subject may seduce us by the arrangement of its chiaroscuro; another by purity and decorative arrangement and intention of line; another by mere beauty of colour almost devoid of form. Again, these three elements may each and all contribute to the eye's delight. We must obviously choose a technique fitted to the reproduction of the particular perfection of the landscape. The grey-greens, delicate and slightly varying though they be, of the Provençal Alpilles are almost meaningless if reproduced in vague and floating colour. The contrasts are insufficient, the sketch is almost a monochrome; the soul of the thing lies in the extraordinary movement of the form clear against the silvered azure of the sky. The form of a London street is hideous. Whistler has produced some admirable ' Nocturnes ' by suppressing form entirely, and employing the veiled gradations of foggy air and skilfully managed light and shade to suggest impenetrable mystery. At Venice the sketcher may safely let one half of his form go to the dogs, and be content to revel in shimmering

[1] The frontispiece is an example of the pen-and-colour method applied to the rapid noting of a fugitive evening effect.

wealth of colour, where the rose of palaces sinks indefinite into a languid sea; itself wrought over and over with tissue of many-coloured light.

How often a sketch fails because the artist has not run to earth the veritable cause of his emotion; and has not concentrated all his power and knowledge on the reproduction of that vital thing! This lack of analysis on the part of the world in general is what prevents people from ' understanding ', as they say, many an admirable sketch. They do not see that what is reproduced is the essential thing that stimulated the artist's constructive spirit. They do not see that what is represented is really what would have arrested their own attention, supposing they had been there. It is only divested of extraneous matter, an operation they would not have been able to execute, and do not know how to appreciate when it is done; for to analyse exactly one's own sensations is a difficult, a most difficult task.

Finally remember that any great European composition is invariably founded on a scheme of straight lines and planes ; the curved elements are of secondary value. There is a great tendency in England to ignore this fact ; and of all the great English artists Turner has, it may be, utilized the straight line least. I point this out on page 60, which should be read with the analysis on page 92. Such lines (see also the analysis on page 101) are for the most part imaginary. They are created in a crafty way by judicious accent placing, or by the prolongation of a real line, limiting an element of the composition, by some other line which belongs to quite a different object.

LATE TURNER SKETCH OF THE GRAND CANAL AND DOGANA, VENICE

By the courtesy of the *Connoisseur*

For analysis see p. 99

IV

VALUES

A VERY important part in imitative painting is played by what are technically known as ' values '. Value is that part of the visual impression we receive from things which is not attributable to colour, but to the *quantity* of light they give out or reflect. The estimation of relative values is not easy even to the most experienced eye. If a light dusty road is bordered by dark green foliage, it often appears lighter than the sky. It may really be so; and the best way to find out which of the two is the lighter is to hold up at arm's length, before first one and then the other, some such object as a cork, or even one's thumb, taking care that the cork is inclined at the same angle in each case, in order that it may receive the same amount of light and consequently be itself of constant value. It will then appear to be darker against the lighter background, and lighter against the darker one. In this way we may compare the values of widely separated things. It is rare to encounter pictures in which values are thoroughly understood and managed; and I cannot exhort you too much to pay attention to their study. On them depends a great part of the luminosity of your work. How often do we see ambitious sunset sketches, wherein the vermilion source of light is one of the darkest details of the picture.

Luminosity is attained by a kind of sliding-scale adjustment of value contrast and colour opposition; but do not suppose that dark shadows increase the luminosity of the lights of a picture. On the contrary, we only find dark

shadows when the quantity of light is feeble, as in moonlight or lamplight; in the luminous lands of the sun, the shadows are hardly darker than the lights; they are filled and gilded with reflected light, and are more coloured than the lights themselves.

As a rule the arrangement of values in a landscape is very simple, and Corot used a dodge, in making rapid sketches, that might with profit be adopted by every one. He contented himself with reducing all his variations of values to four groups, which he numbered from 1 to 4, and wrote the corresponding figure on the part of the sketch that he judged to enter into that group. I quote some doggerel lines due to his pen; on them sketchers would do well to meditate:

Reflexions sur
la Peinture
les deux premières choses
à étudier — c'est
la forme plus les valeurs.

Ces deux choses sont
pour moi les points d'appui
et sérieuses dans l'art.

La couleur et l'exécution
mettront le charme
dans l'œuvre.[1]

Accustom yourself to estimate the lightness or darkness of a tint as separate from its colour, and to translate this estimation into a pictorial value of possible representation. The natural scale of values is far beyond our palette's

[1] Reflections on Painting, The two chief things to study—are form and values. These two things are for me the base and serious parts of art. Colour and execution will give charm to the work.

reach; the highest note of nature is sunlight itself; ours is simply white. At the same time pure black on illuminated paper is much lighter than the complete, or almost complete, absence of light. What we have to do in a picture is to preserve the relation of the values as far as possible; our scale is shorter than the natural one; but if a value in the natural scale be placed, say, at two-thirds of the distance from the highest light to the darkest shadow, we must place it at two-thirds of the distance between the extreme values of our picture. Some artists deliberately shorten their schemes even below the possibilities of the palette; a few choose their range entirely in the lighter half; many remain entirely in the darker part; some content themselves with high lights that others would almost reject as deep shadows. In every case the luminosity depends on the correctness of the relations of values; and not on their absolute degree of blackness or whiteness.

The method of comparing values by means of a cork held up in front of the subject is only useful for occasional comparisons. It will not help us to see an arrangement of values simply, or to make a simultaneous comparison of all the values. To this end the black mirror was invented; but personally I do not like it, and never use it. All brilliance of colour is destroyed by it, hidden by a sombre veil; and it seems to me difficult to use, so to speak, two different impressions of what one is painting. I believe the use of the black mirror inevitably entrains the artist into a darkening of his key and a sacrifice of clearness and brilliance of tint. A simpler way of arriving at the same result, and at the same time seeing one's subject broadly, is almost to close the eyes till one just perceives the subject through the eyelashes; this seems to me to give just as useful a result as the black mirror, with the additional

double advantage of not costing anything, and adding nothing to the apparatus one has to carry about; which, even at its slenderest, is always more than one would wish. I myself, delighting in bright colour, do not use either of these ways of seeing my subject simply. I have cultivated the habit of closing one eye, while leaving the other wide open, though I throw it, by a voluntary effort, quite out of focus. I thus see my subject deprived of all confusing detail, and as broadly as I wish—by throwing my eye more and more out of focus—though the brilliance of colour is in no way interfered with, it is on the contrary rather easier to see; for one sees it as colour only, freed from explanatory form, which always tempts the judgement to modify the pure colour impression. Some people find a difficulty in throwing the eye out of focus; the following method may help them: Hold the finger up about six inches from the eye and look at it; then, making up your mind not to change the state of the accommodating muscles of the eye, suddenly remove the finger; you will see all the objects before you, at a greater distance than six inches, enveloped and without detail. I have found this dodge most useful in constructing a simplification of an over-detailed subject, and cannot advise others too strongly to cultivate it. Of course, as one's experience as an artist increases, such methods become less and less necessary; habit allows one to see things simply, or, to express myself better, to see the complication of them in the relative order of its composing elements; but the beginner will find in these methods a fruitful source of inspiration in the massing of foliage, or of flowers in meadows, to cite only two of the innumerable instances.

When you have once separated your subject into a few big masses of one or two values, and have confided this

conception of it to the paper, it is astonishing how few passages and half-tones along the edges, say, of the shadow colour will be enough to make the drawing look complete. I should advise every beginner to choose subjects that may be easily split up into very simple massing in order to accustom himself to the work. Not only will he run a greater chance of making a successful sketch; but he will be training his eye in an excellent way. It is difficult to resist the temptation of trying an obviously beautiful but complicated subject; but yielding will certainly lead to failure and, what is worse, to waste of time, for from failing in such subjects we learn nothing, unless it be not to try again.

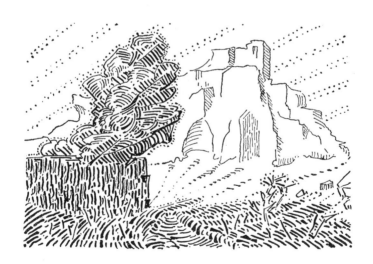

V

LIGHT AND SHADE

DURING the nineteenth century, the century of Romanticism, light and shade played a great part in pictorial representation. The present tendency is rather to reduce its employment as much as possible. But as this book may be read by some who feel that therein lies their most natural way of expression, the subject must not be passed over in silence. For the genuine landscape-sketcher, as distinct from the constructive synthetic artist, there is a still more cogent reason for its study. Many subjects in nature are excellent light-and-shade models; for the representation of the most essential part of their charm colour is hardly necessary.

A light-and-shade arrangement may be distributed over the surface of the paper; but it is more often of a concentrated type; that is, one in which the movements of the gradated shadow tend to lead the eye inward towards a more or less central point of interest, which generally lies in full light.

Rembrandt is *par excellence* the master of concentrating light and shade, in which circumambient shadow surrounds a central light. This is a natural form of expression to an artist of the emotional or psychological type, whose interest lies in analysis and examination of the particular, and not in synthetic suggestion of the general; he concentrates attention on the thing to be examined, instead of, so to say, centrifugating as in the work of Puvis de Chavannes, first literally over the surface of the picture, and subsequently, in a figurative way, outward to ever-widening circles of

general phenomena. I believe that light-and-shade art must be essentially emotional and not general; the contrasts instituted among the values by light and shade when divested of their emotional vagueness of limit become simple black and white juxtapositions (or other absolute value contrasts), as on a Greek vase.

As a rule, then, we have in emotional light and shade a single highest point of light; while shadows, darkest at the frame, run gradating towards it. One may almost safely say that the more one counts on light and shade as a means of artistic expression, the less one is in need of colour; for the less a subject is lighted, the more nearly its colour scheme approaches monochrome, the more it becomes a tint scheme based on similarity rather than on contrast. This is not to say that the light-and-shade arrangement of a picture in bright colour may not make a very important part of the design. Very often an ingeniously used shadow in the foreground will complete an otherwise lacking composition; but it will invariably be found that the shadows and the lights of a high-key, bright colour scheme are more even in value, that is roughly one value for the light and one for the shadow, than are those of the Rembrandt type, wherein subtle gradation is interwoven with yet more subtle, and the whole tends to some central point within the depths of the canvas. Light-key colour does not tend naturally to converge in recession towards a centre; like that of a Florentine fresco, it tends to lie evenly over the surface.

To divide such an integral subject as painting into different parts, as I am trying to do here on account of the exigencies of explanation, is an unsatisfactory task. The subject of light and shade is intimately allied to that of values, without, however, being exactly identical with it;

for a dark object in full light may be darker than a light object in shadow. It is very difficult to know whether to discuss such a point in this chapter or in the one accorded to values. It seems to me to be better placed here, for the real value of an object (measured by its capacity for absorbing or reflecting light) is a more constant thing than the superadded shadow or light; consequently the phenomena arising from this addition should be treated in the chapter devoted to light and shade.

The eye, unaccustomed to judging relative values, is very often taken in by the relative effect of a dark object in sunlight and a light object in shadow. The usual error is to make the dark one too dark, and the light one too light; thus destroying the unity of both the light and the shadow parts of the picture. Obviously I cannot do more than point out the possibility of the mistake, and advise the use of one of the suggested means of comparing values. But forewarned is forearmed; so recognize both the frequency of this error and the importance of not making it. Seen from a few yards off, your sketch should appear as a simple arrangement of light parts and shadow parts, the simpler the better. Any tone in the shadow, so decidedly lighter than the rest of the shaded part as to interrupt the feeling of unity of the latter, will probably be wrong and should be examined; while it should always be remembered that even pure black in full sunlight is lightened, silvered, filled with colour in its own particular shadows; which are again seen through a veil of light; all this to such a degree that it becomes no darker than a half-toned object in the foreground shadow.

Modern European 'representational' artists, by which I mean artists who try to paint pictures as like the real subject or effect as possible, seem to be broadly divided

EXAMPLE OF IMPRESSIONISM. RENOIR, 1875

Photograph : Durand-Ruel

For analysis see p. 100

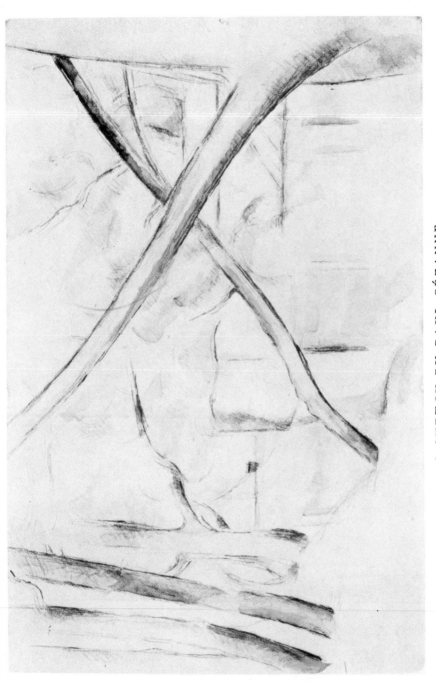

A SKETCH BY PAUL CÉZANNE

By the courtesy of Sir Michael Sadler

For analysis see p. 102

into two classes: those who aim directly at the effect, as
Monet, Sisley, or Renoir; and those whose first preoccu-
pation is the actual solidity of tangible objects, the effect
only being considered in the second place. Such a painter
was Cézanne. This second class is by far the more rare.[1]
Obviously you must choose for yourself your own line of
march; and success will probably attend you in proportion
to the degree of clearness with which you make up your
mind as to exactly what you are aiming at. The usual
failing of most amateur work is vagueness of primal in-
tention; or, as I have said elsewhere, failure to analyse
correctly wherein lies the particular charm of the subject
whether in form, chiaroscuro, or colour. If it be the
arrangement of light and shade that is the seductive ele-
ment, decide whether it is of the simple flat kind, such as
a street with one side sunlight and one in shade, or a field
with a tree or other shadow cast across the foreground,
beyond which the rest of the picture develops in an expanse
of sunlit grass and distant foliage; or whether it is of the
profound or Rembrandtesque type, such as we may some-
times find in the quaint narrow abrupt streets of an Italian
town where the want of width in the foreground condemns
it to lowness of tone, but beyond a still more sombre archway
we catch just a glimpse of lighter things. Here all the *intime*
charm lies in the delicate gradation and movements of
shadow on the house walls to our right and to our left; they
must be studied and carried out in such a way as to lead
the eye from every point to that principal one beyond the
arch. The immediate contact of the dark shadow of the
arch with the highest light will of course add an appearance
of still greater sombreness to the former. In order to obtain

[1] Written in 1914. Now a visit to a modern Parisian Salon will give an exactly
opposite impression.

our light effect we must imitate these differences of value, which depend not only on the real nearness of the shadow to the light, but also on the position of the artist's point of view. If you advance towards the light, nearly to the end of the shadow, you will find that the house walls appear lighter on your immediate right and left than they did when seen from farther off, when perspective approached them to the light. But we must beware of lightening the foreground too much and thus destroying the unity of the shadow and the essential difference between it and the light which is destined to produce the general relative effect that renders our picture luminous. Again, as I have said, too dark a distant shadow is fatal to light and air; we must carefully study and establish an equilibrium among these rather conflicting elements.

One of the subjects from which it is easiest to obtain an effective result is the silhouette of trees, or other objects, against an evening sky. This is due to the fact that nature herself announces the method of simplification in a very evident way; in which the rare contrasts, hardly more than the two main ones, are of so marked and violent a kind as to be easily grasped even by the inexperienced. Add to this the palpable, and somewhat done-to-death, ' poetry ' of an evening effect and we have all the elements of facile success at hand. Such subjects perhaps make very good exercises for the beginner; for they accustom his brush to breadth of treatment; and he learns how little detail is really needed to make a sketch sufficiently suggestive.

VI

NATURE OF COLOUR HARMONIES

To the artist no colour exists by itself. It is all very well for the physicist to tell us that B red light is 434,420,000,000,000 oscillations of the ether in a second; so it may be. But as an artist never sits down to paint a hairbreadth line of monochromatic light penetrating into complete darkness, the absolute isolated nature of that light is of no importance to him. Not only is this so, but were he to try to paint his line of red light, he could not do it, at least not by drawing a line of red paint on black; red letters on a black ground do not appear luminous.

Still it would not be impossible to paint the effect of the slit of red light in complete darkness, and this is how we must set about it. We must neither paint the light nor the darkness; we must paint the relation between the effects of each simultaneously on the retina. Now the apparent effect of a pencil of red light on the surrounding obscurity would be to impart to the latter a greenish tinge; by carefully studying this relation, and adding to it reproductions of diffusion effects due to dust in the air, refraction, &c., we might obtain a very tolerably luminous representation of our subject.

After all, in imitative landscape work the main quality we try to get into our colour is luminosity, whether the luminosity be the intense light of the south, or the mysterious silvered illumination of more subdued climes; and we may safely say that the degree of luminosity of an artist's

colour is an exact measure of his capacity as a colourist. Obviously the more subdued the light is, the more it falls within the possibility of representation by means of the non-luminous colours of the palette; on the other hand, the more dazzling and splendid it is, the more we are obliged to take refuge in artifice and exaggeration in order to suggest it in paint. We may roughly divide colour work into two classes: one of which attempts harmony by similarity of tint, that is, by a uniform greyish or brownish (or other) tendency; and the other which aims at adroitly arranged shock of colour contrast. Notwithstanding the fact that silvered schemes require an exceedingly delicate eye and artistic sensibility for their confection, I am inclined to think that they are easier to manage with, at any rate, considerable success than are opposition schemes; in both cases the main difficulty lies in the shadow colour. If in the first we can keep our shadows from being opaque, and fill them with air, we are successful, whereas in the second case we are confronted with the additional difficulty of the necessity of determining a very decided colour often in exact opposition to that of the light. In grey schemes the shadow colour is often hardly more than a darker tone of the light. For this reason I shall pay more attention in what follows to the second, or opposition ideal.

The choice of method depends on the artist's personal tendencies and on the localities wherein he seeks his subjects. There is, all the same, no distinct line to be drawn between the two methods, and most people nowadays hover in an undecided fashion between the two.

As a rule the ' harmonious ' method in landscape work tends somewhat towards expression by means of light and shade contrast, while the colour tends towards monochrome. Diffused lighting suppresses or reduces to a minimum the

difficulty that all painters find in establishing a relation between sunlight colour and shadow colour. In order to extend the representative powers of our non-luminous palette, we bring into use the startling effect on the eye produced by juxtaposition of more or less complementary colours. We all know that the complementary of a red is a certain green; of a blue is a yellow; or more exactly red and greenish yellow are complementary, so also are orange and Prussian blue; yellow and indigo blue; and, lastly, greenish yellow and violet. By placing the two colours of any one of these pairs side by side we may be sure of obtaining not only the most violent colour effect possible,[1] but also a certain degree of luminosity.

If we look carefully at the edge of a cast shadow on a dusty road in bright sunlight, or rather if we look at both the light and the shadow, we shall see that while the light part of the road appears to be composed of pale bright yellow, broken with rose, the first few inches of the shadow are of an intense blue colour; which again cedes farther on, in all probability, to warmer orange and violet tones. When you have observed such a fact, do not be afraid to render it; do not be afraid to paint your blue too blue, nor your yellow too yellow; I have never known a beginner's painting err on the side of colour too pure. The defect is always in the contrary direction of muddy, over-mixed, opaque tints.

One day, when challenged, I succeeded in painting an oil sketch of a grey still life, to the satisfaction of my challenger, without using a single mixed tint; that is, I used nothing each time but a pure colour from the tube mixed with more or less white to obtain the correct value. It was admitted that I had obtained the desired 'quality'.

[1] This is not quite correct. It may be upheld that a vermilion and a violet juxtaposed give a greater shock than vermilion and green.

The explanation of what may seem to be a *tour de force* is really very simple. The great mistake that most painters make is not to understand clearly what they are doing. Colour for colour they cannot imitate; all they can do is to establish a series of colour relations which shall suggest the series of relations established in the landscape by the inter-action of local colour and colour of effect due to lighting. The relation between 2 and 4 is the same as that between 3 and 6, namely $\frac{1}{2}$; yet 2 is not the same as 3, nor 4 as 6; moreover, there is a limitless number of relations, each equal to that between 2 and 4, for example that between 50 and 100. This is roughly the reason why two painters of equal skill and equal sincerity may paint the same subject and produce two pictures, both of the same excellence, yet totally different. One painter has chosen to reproduce the natural relation between 2 and 4 by 6 and 12, the other by 12 and 24; the ratio, all that is essential, is preserved. By a properly established series of ratios one can represent a grey effect with pure colour, just as well as one can paint sunlight by using a different series of relations *of the same tints*.

Before beginning to paint, one must have a clear colour-idea of the landscape; that is, one must have translated the natural appearance of nature into a possible palette scheme; and not till one holds this idea firmly should one start. The greater number of painters, especially water-colourists, generally have a ready-made arbitrary scheme of colour into which they force all natural effects. Such a man brings back from a Bombay street exactly the same colour scheme as he would obtain in an English village; on seeing his work in a gallery we know at once that it is an X . . . from its tints alone.[1] Whether this proceeding is justifiable or

[1] This is not the same thing as recognizing a Turner or a Monet from their individuality as artists; both dealt in most varied schemes invented each for its particular effect.

not would take us beyond our present limits into theo-
retical aesthetics, so it must be left aside; but we may at
least affirm that such a convention is a great simplification
for the artist, his work and risk of failure are reduced by
half. Always painting in the same scheme he, so to speak,
learns it by heart, its possibilities, its limits; he only uses
the landscape as a hint for new linear arrangement and for
the placing of his different previously invented tints. If
the reader wish to follow this school, he has only either to
copy a ready-made scheme from some other artist, or
experiment until he finds one suited to himself. Such
method has the great advantage of allowing its user to
produce effective work much sooner than if he had studied
the possibilities of the whole palette instead of learning
the possibilities of one limited scheme of colour. If you
have no personal predilections, a safe and comfortable
scheme may be made out of the early English water-colour
tints of burnt and raw sienna, Antwerp (or Prussian)
blue, yellow ochre, and light red; which will probably
appear in the finished work in about that descending order
of proportion, unless the subject be a very green one, domi-
nated by much blue sky, in which cases the Antwerp blue
would take precedence, either pure or mixed with raw
sienna, in order to give the only dark olive greens obtain-
able in this scheme. A slightly more ambitious one would
be obtained by adding gamboge or Hooker's green to our
palette, thereby opening up the range of greens. But the
actual means of obtaining tints belongs more properly to
the special chapter upon it; so here I will limit myself to
saying that, for facility in discussion, I divide colours into
two classes : the first containing the sombre earth-tints, the
siennas, ochre, light red, and so on; the other being made
up of tints such as aureolin, rose-madder, and cobalt.

Naturally this division is more than arbitrary, for with the siennas one would use Antwerp blue, which is a colour alike indispensable on the brighter palette. This, indeed, is the difficulty in writing on such a subject as art, which allows of an infinite series of manifestations; if one expresses ideas in phrases and forms of perfectly general applicability, they are so general as to be of very little help to the practical painter; unless he be already very experienced, when they may be the cause of reflection on his part, and thus bring about a change in his methods. One is thus forced to choose and classify arbitrarily, in hope of being of some practical use at the expense of general exactitude.

Those who wish to use colour as an agreeable vesture for a drawing will then only have to make a few experiments in colour harmony—based perhaps on the chapter on colour mixing; decide once for all on their scheme and translate every colour arrangement they may meet into it.[1] On the other hand, those among us who would more ambitiously attempt the rendering of the spirit of colour, the soul and essence of effect, I will now try to aid a little on the difficult path along which so few advance far from the starting-point.

The great difficulty in the plastic arts is to feel one's subject as a whole. Good colour is colour seen integrally. The exact tint that makes a dirty and evil shadow on one canvas would make a transparent and harmonious one on another : all depends on the relation established between the colour of the light and the colour of the shadow. *Hence we must never look at the object alone that we happen to be painting at the moment*; we must *perceive* it in its relations to the other parts of the whole. Suppose that we

[1] The necessity for changing every note, if we change one, will be understood by the musician who is used to transposing.

are painting a street of stone houses, part of which is in shadow and part in light. If we look at some particular stone in the shadow near us, we shall probably see it in its local colour of grey. If, however, we *look at* the sunlight and *perceive* the stone, in an aside so to speak, we shall see that it takes on a determined tint, perhaps blue, perhaps violet or orange, according to the circumstances. It is from this perception that we take our colour inspiration for painting. It is a curious thing that all ordinary instruction should be contrary to artistic training; a newly born infant probably sees much as a trained painter does; with the difference that it has no conception of distances (the greater number of artists have but a very imperfect conception of modelling in the third dimension, to and from them); it receives on its retina general impressions of colour to which its inexperience prevents it from attaching a meaning. Now it is much more useful in practical life to recognize local colour under different effects, than it is to register the colour of effect. The important thing for the ordinary person is to know that stone is grey; and not that under certain conditions of lighting it may be blue, or green, or orange; so we unconsciously train our brains to analyse the retinal impression; to keep the permanent or grey quality of the stone; to cast aside the transient or the colour of effect, which latter is what the painter carefully gathers up. The truth of this was displayed to me in a startling way one day in Italy. I was talking of colour to a lady who was not an artist. Before us, and between us and the window, was a polished mahogany table in which the blue of the sky was reflected, only a little enriched and lowered in tone. I pointed out to her that the table was blue. ' No,' she replied, ' it is brown.' So firmly was the knowledge of the brownness of mahogany anchored in her

mind that the impression of blue light received by her eye
was powerless to shake it. But remark, had I painted a
picture of the room in correct colour and value relations,
she would have had no fault to find with the painting;
her mind would have carried out the same process *vis-à-vis*
the picture, and she would not even have seen the blue
paint on the represented table-top.

In practical life we have ribbons to match or clothes to
buy which are destined to be seen under different lightings;
so what interests us is not the real appearance of the ribbon
or cloth at some particular moment in some fixed lighting,
but a kind of vague general and usual impression of colour,
the average of many impressions. The greyer and more
diffused the lighting, the more the real impressions of
things, those that we may use in painting, coincide with
these average impressions. Hence it is easier to get a decent
result out of grey subjects than from bright sunlight or
unusual effects; though to make a real success of grey
schemes of course demands a very delicate sense of the
perfection of colour rhythms.

Seeing the real colour of effect is much aided by the
trick of throwing the eye out of focus, of which trick I have
spoken in the chapter on values. By not focusing the eye
on any particular point we see all the parts of the subject
at once and in an equal degree; and thus correctly receive
the integral impression of the relations between light-
colour, shadow-colour, and so on.

Probably any one not afflicted with a defective colour
vision might, with application, arrive at producing fairly
good colour, if assisted by intelligent instructive criticism.
At the same time it is not easy to lay down a series of rules
of somewhat general application.

If the tint that you have chosen for a tree trunk does

not harmonize with the tones in the foliage, it must be abandoned, and another one sought. You may be sure that you have not looked at the tree as a whole. Before all things your sketch must be a harmonious system of colour; it must be thought out in the same way as that in which the colour of a ribbon is chosen to harmonize or ' go with ' the colour of a dress.

A very good exercise in colour and value, for those who have the patience to carry it out, is the construction of a table of complementary colours in value. Take a fairly large sheet of paper and divide it vertically into nine equal parts and horizontally into thirteen of the same size as the others. The top left-hand square we will leave white; the bottom left-hand square we will paint as black as possible with Indian ink. These two notes are the extreme limits of the palette in value. The seven intervening squares we will call, in descending order: high light, light, low light, middle tone, high dark, dark, low dark, which last is followed by pure black, the negation of light and colour.

Now try to fill each of these squares either with diluted washes of black, or with mixtures of black and white, contrived so that the gradation from white to black should occur from square to square in an even way down the column. If this be successfully executed it will provide us with a scale of values. In the remaining squares we are going to install the colours in the order of the spectrum, beginning in the second vertical column with red. But the different colours are far from being of the same degree of luminosity, and none is of so high a value as white. Thus the reddest red that we can obtain is a mixture of Chinese vermilion with a little rose-madder; which gives us a tint already dark in comparison with light cadmium, for

instance. On inspecting our scale of values we should find that its proper vertical place is opposite the high dark square; we accordingly tint the sixth descending square of the second column with our mixture of vermilion and rose-madder. By adding white or diluting with water, we then fill, one by one, the four squares immediately above it, namely those opposite the middle tone, the low light, and the high light. The two squares immediately below the pure red square we fill with mixtures containing progressively more dark madder, trying to make each equal in value to the corresponding value square. Horizontally opposite the white and the black square we shall fill in no colour at all; for no colour is as dark in value as black nor as light as white. Those two lines, save for the initial value squares, will remain empty. The vertical row after the red is destined to orange red; then orange in the fourth column, followed in order by: orange yellow; yellow; yellow green; green; green blue; blue; blue violet; violet; and violet red in the thirteenth and last column. Each vertical column must of course be gradated in values as was the red one. If the work has been properly done, the purest orange red will be found to be opposite the middle value, the orange to correspond with the low light, the orange yellow with the light, and the purest most yellow yellow with the high light. From this point we begin anew to redescend in luminosity, as pure white is of course unattainable as a value in colour; yellow green being on the level of the light; green on that of low light; blue green is opposite middle; blue is a high dark, as was red; blue violet is a dark; while real violet is a low dark. Red violet completes the cycle by being anew a dark; whence we should begin again with the high dark red.

The construction of such a table is a tedious job; but when you have executed it you will have a far better idea of the nature and possibilities of colours than is obtainable by any other means in so short a time. You will have found out how to obtain any degree of lightness or darkness of any tint; you will learn which is the theoretical complementary of any one of the tints figuring in the table; it is the seventh counted horizontally from the colour. Thus the complementary of pure red and in the same value is high dark green; and these two colours placed side by side give the most violent colour effect that we can obtain from either of them juxtaposed with another tint. The complementary of pure blue violet is dark orange yellow; for, of course, one counts to the end of the table, and then begins again at the red to complete the seven squares. When the table is properly adjusted with equal differences of colour and value between any adjacent squares, a most curious effect of light is produced. Two juxtaposed triangles of gradated light and shadow seem to take the place of the merely tinted squares, and the errors in colour and value are at once evident as holes in the luminous gradation; naturally they should be corrected. It is as well to try each tint on a bit of pape-before irrevocably confiding it to the table.

A few suggestions as to mixtures that will give the required tints. It is in making such a table that we realize how imperfect are the colours at the artist's disposal; to get a low dark red we may be able to use a dark madder, but we may have to introduce a violet touch which strictly speaking should not be allowed. Crimson lake and vermilion may be found to give a fuller red than rose-madder and vermilion, but the purest red of the spectrum remains unattainable, as vermilion is often slightly yellow, and

crimson lake is slightly violet. In the interval between the red and the yellow columns, we must do our best with aureolin—or the cadmiums, if we have them—yellow ochre, raw sienna, and burnt sienna, the light oranges being aureolin—or cadmiums—mixed with madder or crimson lake; the darker ones being obtained by raw or burnt sienna and crimson lake. As a rule it is the darker tones that are the most difficult to manage, except the violet, which is itself dark and is given by a reddened mauve (mauve as an artist's colour is much bluer than the tint generally known under that name). The yellows and yellow greens have a tendency to brownness when we darken them, as we are obliged to use the siennas, for lack of pure, dark yellows. The green column may be managed almost entirely with viridian as base, modified with aureolin or a cadmium; though the darkest green may be the result of raw sienna and Antwerp blue. In the blues, cobalt may be used in the upper part; ultramarine will carry us nearly if not quite to the lowest line; if it do not, a little Antwerp blue will help it out. The violets and red violets offer no particular difficulties with crimson lake and ultramarine or cobalt.

This table also shows us some of the tints that we may use juxtaposed or broken one into the other, in order to give more vibration to a tone, without, however, interrupting its simplicity as a value. As long as the values are kept simple and broad in treatment, we may separate the colours which compose their expression as much as we like; such separation will only add air and light to the picture. It is an irregularity of values which gives a disagreeable feeling of confused complication to work, and not a variety in colour, which is hardly ever varied enough. Indeed, one of the great advantages of water-colour is the

way in which one colour may be made to run into another, giving most agreeable broken colour as a result. Some painters in oil-colours make water-colour sketches of their subject before attacking the serious picture, only on account of the suggestions of varied colour that the accidents of the sketch give them.

It might be well to notice that it is important to enclose in a sketch all the essentials of a colour scheme; but that it is not always necessary for the tints which make it up to be each exactly in its right place. For example, if in studying the total mass of a tree I observe that there are blue-grey sky reflections on the shiny upper sides of the leaves; that a certain quantity of light and dark green, seen both by reflected light and by transparency, accompanies the silvering of the light from the sky; and, lastly, that the twigs and branches, to say nothing of the complementary appearance of the shadow tones, provide a scale of blues, of purples, and of browns; it will be very often quite enough to run these several tints together in a broken way without paying any particular attention to their relative placing. What really pleases and is expressive in a sketch is, after all, the colour idea expressed; the actual placing of the factors of that idea is often of minor importance.

I have perhaps not made sufficiently clear what is meant by a colour idea; it is that scheme of colour either invented entirely by the artist, or in part suggested to him by an arrangement of colour in nature; it is his transcription of the latter. One looks at a landscape effect, and one gets a certain idea of the way in which it may be transcribed into certain blues, greens, purples, and so on that we can obtain by mixing on the palette. Sometimes these actual tints will bear but little relation to actual and individual tints before us in the landscape, but the relation they bear

to one another must suggest the relation which exists between the real and luminous tints of the landscape, that is if we wish to suggest the effect. Each artist invents a different transcription of these relations, or, in other words, creates a different colour idea.

A colour idea may either be of the ' shock ' type or of the ' rhythmic ' type; or it may be of a kind intermediate between the two.

By a shock of colour we mean the sudden and clearly made juxtaposition of tints, as often as not quite opposed, perhaps even complementary to one another. This sort of colour expression allies itself rather more naturally to a clearly determined formal expression; though we can, of course, almost juxtapose enveloped tints such as those that we obtain by working on very wet paper. Still, in this case the juxtaposition is very imperfect; for the envelopment itself is nothing else than an infinitely subtle gradation of notes between the two main tint areas; hence the suddenness, which is the very essential of the principle destined to act on the observer, is at once compromised. It would thus be more correct to class unhesitatingly all enveloped work in the rhythmic category.

Rhythmic colour can either be rhythmic in a complicated and perhaps uncertain way; or it can be so in a very marked fashion. Of all colourists Turner made the most complete use of rhythmically arranged tints. As a rule you may trace colour areas that wind into the recesses of his picture in flexed forms, and pass from, say, a pure yellow note at the frame's edge to some point of unmixed cobalt at the far-off valley's end.[1] Between these two tints may be found all transient variations of the colour theme that extends from one to the other. In his later water-

[1] See p. 66.

colour sketches a sort of undulation of tint is thus established in all directions. It is in the invention of such schemes that a great part of his genius lies; it is just there that he is so impossible to imitate; it is on that subtle undulation of tint that he relies for much of the illusion of immeasurable space.

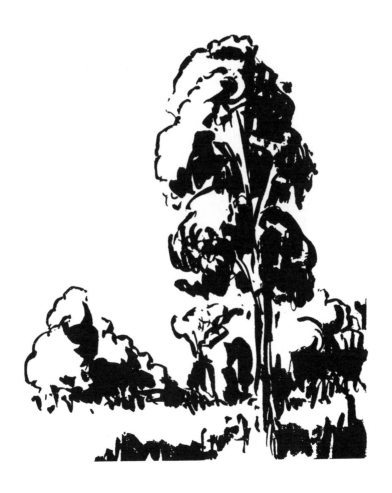

VII

SIMPLIFICATION

Simplification may be ultimately identified with choice, and as such has already been either openly or tacitly considered. Really, the essential of successful simplification is the choice of a subject that lends itself to simple treatment; one in which things resolve themselves naturally into large and decoratively arranged masses. There are of course three kinds of simplification: that of values; that of form; and that of colour. They are named in the order of their relative importance, the simplification of values being by far the most necessary of the three. Both simplification of form and of colour, according to the aim of the artist, may or may not be carried out; but ill-controlled values must bring with them non-success. Values must be reduced, either to simple uniform areas, or to some simply conceived light-and-shade scheme, in which, though the values are infinite in number, they are compelled to follow certain large movements of gradation. In the latter case the simple conception of the movement of gradation takes the place of the direct simplicity of whole areas of equal value.

In direct landscape painting simplification of drawing is so closely allied to that of values that certain impressionists were able to proclaim that drawing *is* values. Such a statement causes a needless confusion between two quite distinct subjects. What is really meant is this: when with half-closed eyes (or with the eye thrown out of focus) we look at the whole mass of a tree detached against a back-

ground, the form or drawing of the tree is only indicated by the limits of the differences of value between the different parts of the tree amongst themselves, and against the background.[1] The solid sense of modelling in imitative painting is due to the representation of the relative values of the surface colour. Naturally, if one places the various areas of equal value rightly, the object will appear to exist, will be drawn, in other words, if we do not—as the impressionists did not—enter into questions of suggestive or expressive movement of surface, or of its result: contour. In this sense, and in this sense only, drawing is the same thing as values. If, however, we suggest form by a contour, this contour may be simplified in two ways. First: we may aim at the simplest geometrical representation of the rough shape of the object; and, by suppressing the detail of a tree, assimilate it more or less to the shape of a hemisphere, or a cone, as the case may be; while all we seize on in the branches is their cylindrical shape; or, secondly: we may seek to extract the essential of the rhythm of the form, and try to express that rhythm in the simplest and most concentrated way. Naturally these two simplifications of the extraordinary complication of nature should be subtly combined in our presentation of her. The intentionally myopic vision, of which I have so often spoken, is very useful in arriving at both forms of simplification; by seeing the light and shade in a simple way we get a simple idea of the reduced geometric, spherical or other, shape of the tree mass; and, by the suppression of superfluous sprays and other details, we are enabled to see the essential large movements of the contour. It only remains to combine both these qualities in one suggestive line.

[1] Strictly speaking, the colour may or may not play a part in this determination of form.

The beginner will probably never simplify his values enough. That is why I suggest sketches of tree or other masses in silhouette against an evening sky, in which case the values may be easily reduced to three; namely: the dark one of the tree mass, the hardly lighter one of the foreground grass, and the third contrasted value of the sky. In such a sketch the main artistic idea lies in the violent contrast of light and dark, slightly modified by the second value. This would be an instance of simplification by extreme separation of the composing factors. On the other hand, one might represent a full sunlight effect, the sun full on the subject, by a studied equalization of values and depend entirely on the colour oppositions to give the effect. But in whatever scheme of values we work, we must always seek to keep large stretches of the picture more or less in the same value; and avoid breaking up these masses by unnecessary variety or accents.

In the frontispiece there are only three main values; unless the grey of the mountain on the right be counted as a fourth. In reality it is scarcely darker than the sunlit grass on the left; though the fact of its being grey instead of yellow renders it far less luminous. The other two values are those of the foreground of grass and the darker line of trees and bushes that bound it, and run diagonally across the paper. The sky is scarcely lighter than the sunlit part of the picture. These three or four areas of equal value are kept as simple as is consistent with the suggestion of the existence of details in the landscape; in every case value-simplicity is given precedence over detail indication.

Colour, I have said, may or may not be simplified. In the example we are considering certain main groups of colours are of course maintained. The green of the foreground, the blues and purples of the trees, the yellow

green of the first mountain, the grey of the second one are
so many groupings or simplifications of colour, which could
easily be rendered more simple still as we approach a
decorative, or *stylisé*, rendering of our subject. However,
in the kind of painting which aims at representation or
imitation, variety of colour, if kept within certain limits,
and if kept strictly to the same value, is of great use; not
only to diversify tracts of equal value and single colour-
intention, but also to render the colour more airy, more
vibrant, and consequently more light-suggesting. At the
same time all such variations should only be allowed to just
such a degree as does not destroy the main tint of the
particular part of the picture.

It is in the reduction to a simple expression in form, in
colour, and in values that the chief part of the plastic idea
of a painting is to be found. Such a sketch as the one we
are examining is in no way the product of a desire to
produce a representation of the valley of Château d'Œx;
it is the noting of a sudden and transient arrangement of
colour and values which took, at a certain moment, a
decorative shape. The intention of the picture is the
interweaving and decorative juxtaposition of the various
yellow-green, green, grey, and blue-purple parts; any
additional detail or finish must be kept subservient to the
fundamental idea, which first appeals by its simplicity.
Every successful picture is built up on some such simple
and decorative arrangement. An excellent method of study
is to take a sketch-book into a picture gallery; then to
seek by means of hastily scribbled and most shapeless
masses of values the fundamental decorative intentions of
pictures of different schools and different epochs. Such
decorative intention is unconnected with the nature of the
objects represented; a light patch may be indifferently

a nude or a sunlit tract in a landscape; the decorative principle involved will be the same. Much, if not most, of the artistic value of the finished work lies in the degree of excellence of this primal decorative idea.

One of the great practical difficulties of art lies in the elaboration of a basal idea in such a way as not to confuse and destroy it. In plastic art, perhaps the greatest examples of success in this way are to be found among the Greek marbles of the fifth century. Close attention will discover plane upon minor plane so subtly juxtaposed as to be almost invisible; they seem to form a surface of one simple untroubled curve. But it is difficult to see the exact application to water-colour sketching of the lesson that may be learnt from a Greek statue; a more useful study can be made, in the later water-colours of Turner, of the way in which he has piled up a profusion of detail without destroying the unity of the three or four main colour movements of his scheme; these generally run back in a conical gradation from the edge to the central point of interest.[1] In the case of Turner, the complexity is superimposed on a simple conception of gradation of colour and values; and not on a direct simplification of ungradated areas of them, as in an Italian fresco. Between these two extremes the artist must choose the kind of simplification best fitted to express his own mental standpoint; but some kind of simplification he must use if his work is to be successful.

.

Just as the sketch passes by slow degrees towards the finished and completed picture, so an account of the ways of its production may extend itself indefinitely, until it embraces the whole technique of painting. It is difficult to assign any fixed limit to the know'edge that is required to

[1] See p. 60.

make a good sketch. Obviously one can never know too much; on the other hand, those who study seriously often traverse a kind of interregnum of inferior work, during which period they are discontented with their first results, successful on account of the small ambition of their aim. The artist would fain attack difficulties directly instead of avoiding them; but as yet his knowledge is insufficient; he is defeated.

It may be as well before closing these pages to pass rapidly in review the principal points which we must bear in mind when we desire to produce a good sketch.

In the first place we must never allow ourselves to be enticed into the making of a drawing on account of some single interest of detail; such as the colour of flowers, or the interest of a fragment of architecture,[1] or, again, the desire to preserve a souvenir of some place to which sentiment attaches us. We must only sit down to work when we are in clear possession of a ' plastic ' and decorative idea of arrangement, both of form and of colour; which, *though it were carried out in so indefinite a way as to render unrecognizable the various natural objects, would still preserve its decorative and, so to speak, purely artistic value.*

In the same way, not only must we have before us a complete conception of the decorative placing of the various tints on the sheet of paper, but we must have an equally clear notion of their relative harmony. We must mentally see, before executing it, a complete scheme of tints, a symphony of colour, grey or brilliant, light or dark, rich or silvered, into which we shall translate the unpaintable aspect of real things. We must struggle continuously against that

[1] Of course one may obviously make a deliberate study of a piece of architecture, a study such as an architect might make. I am here only speaking of sketches aiming at a pictorial whole.

tendency of the artistically uneducated eye only to compare contiguous tints; we must accustom ourselves to receive whole and integral impressions of the entire subject we are painting. The distant mountain slope which appears grey in the sunlight when we look directly at it, becomes veiled in translucent rose when the eye but perceives it vaguely, and while the main and immediate impression is that of the vivid yellow-green of the grass at our feet. It is these inter-reactions of colour that we must strive always to seize; and on which we must base, each time anew, our colour idea. The whole education of an artist consists in learning to see his subject integrally; to estimate the order of value of each detail; and to subordinate, with delicate accuracy, its importance to that of the whole.

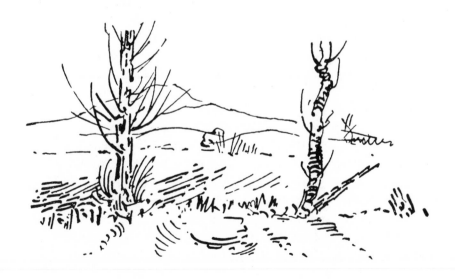

VIII

COLOUR-BOX AND COLOUR-MIXING

THE constitution of a colour-box naturally depends on the subjects and schemes of colour affected by the artist. If a low-toned or grey scheme be that most fitted to express the painter's personality, some such scale as :

>Light Red
>Burnt Sienna
>Raw Sienna
>Yellow Ochre
>Cobalt
>French Ultramarine
>Crimson Lake
>Prussian Blue or Antwerp Blue
>Gamboge or Aureolin

will meet all needs.

If on the other hand the water-colourist should be enamoured of bright colour, and should wish to work amid the gayer tints and sunlight of the South, he would do better to adopt the following list; which, by the by, is the constitution of my own palette:

>Rose-Madder
>(Mauve)
>(Crimson Lake)
>Cobalt Blue
>Antwerp Blue
>French Ultramarine

Transparent Oxide of Chromium, Viridian or Vert
Émeraude (different names of the same colour)
Aureolin
Raw Sienna
Burnt Sienna
Light Red.

These colours are really quite enough to work with; the complicated assortments sold by colour merchants are swelled by such useless additions as: indigo; olive green, and other tints easily and better obtained by mixture on the palette. It is always difficult enough to keep one's colour clean; so it is advisable to begin with the greenest green, the bluest blue, and the yellowest yellow. Moreover the novice wanders amid the intricacies of a multitudinous palette, without ever coming to any satisfactory conclusions as to the results of mixing different colours. As a matter of fact rose-madder, aureolin, Antwerp blue, and cobalt blue are quite sufficient for most purposes. Personally I add Chinese white. I bowed the knee for many years to the fetish of transparent water-colour, but long sojourn in the South convinced me of the foolishness of such a tenet; it only restricts the means of representation at our disposal for no reason at all. The delicate silvered blue of a Provençal sky can never be obtained without an admixture of white. Why should we renounce success because of a current belief—which is not exact— that transparent water-colour is more difficult to execute than body-colour? Transparent work is more suited to the rich humid greens of England; opaque work is absolutely necessary to render the feeling of the dusty sunburnt landscapes of the South.

The two Hooker's greens are useful colours, especially if subjects in which full greens predominate are chosen;

they save mixing the gamboge and Prussian blue of which they are composed.

Avoid olive greens and perhaps even Indian yellow, though I sometimes use the latter myself; such tints are tempting and lead the unwary into the pitfall of hot disagreeable richness of tint devoid of saving and silvering greys. They should be used very sparingly.

As a rule aniline colours should be avoided as they are liable to fade; alizarine is sometimes pressed on the purchaser in place of rose-madder or crimson lake. I have given it up. It lacks in delicacy of tint, it is a more brutal colour. I however use mauve; in which I am perhaps wrong. It tempts me by the facility it offers in obtaining bright sunlight shadow tones. It is also a beautifully transparent colour. Cobalt violet is less transparent, comes off less easily, and dries up quicker on the palette; but is permanent.

If body-colour be used, cadmiums may be substituted for aureolin; which I prefer to gamboge in spite of its high price. Gamboge has a tendency to produce muddy results; it makes great pretence of being clear and transparent, but hardly fulfils its promises. Yellow ochre is a good serviceable colour; raw sienna less so, unless we adopt old English water-colour methods. It is well, however, to have it. Naples yellow is quite useless; vermilion also may be safely dispensed with, though often useful for a brilliant note of red.

Emerald green (vert veronèse in French) may be occasionally used. I employ it either pure or where, by mixing it with aureolin, I obtain the most brilliant green possible.

Transparent oxide of chromium is without doubt the most useful of the greens; it is of a cool and bluish nature and often may be used almost pure in sunlit skies.

Lemon yellow comes off the cake or pan with difficulty; ultramarine ash hardly at all. But it is unnecessary to go on examining the hundred and one colours that figure on the makers' lists; some of them are unsatisfactory in working; others have no other *raison d'être* than providing often-used tints ready made. The latter are chiefly useful to those professionals who adopt a particular scheme of colour and who paint large water-colours, a state of things which necessitates the mixing of considerable quantities of tint at a time, in order to be able to cover large surfaces while the wash is still wet; but the amateur would do best not to encumber his box with them, for they may all be obtained by mixing the more elementary tints. Do not be tempted to think that an elaborate outfit of colours, brushes, and other paraphernalia will render the doing of good work easier. You will get along faster and better if, at the beginning, you force yourself to work with a blue, a red, and a yellow, and thoroughly master their numberless combinations. Always try to use a colour pure and alone; add another if you are obliged to; but only take refuge in the mixture of three colours in cases of *force majeure*; thus doing you will avoid the colourless muddy greys that we so often see produced from the unlimited possibilities of extensively furnished colour-boxes.

Any counsel that can be given with regard to colour-mixing must not be understood to exclude other combinations, of which all are of possible use. All combinations of two colours only, taken from the above lists, may be said to be of fairly frequent applicability. We can, strictly speaking, obtain a very full result by the use of three colours only, a yellow, a blue, and a red; casual writers tell us that by mixing two or more of the three primary colours we can obtain any other. But I have never been

able to understand the exact meaning of the term primary colour. Is it the colour of an infinitely narrow band in the exact centre of a colour range of the spectrum? But how are we to determine the limits of this range? And not only that, but no two eyes see the spectrum in exactly the same way; the physiological personal equation comes into the definition of colour. Purely physical instruments do not agree with us in our classification of coloured light; the photographic plate goes on 'seeing' farther into the ultra-violet, and generally leaves off before us in the red. Any-how the artist never has to deal with pure colours (whatever they may be); his mineral blue is greenish, his ultramarine seems to have a violet tendency, rose-madder has an un-doubted leaning towards the purple, not to speak of the frankly mixed colours green, mauve, orange, brown, and the like. Were I condemned to use three colours only on my water-colour palette, I should probably choose dark-madder, aureolin, and Antwerp blue, though at times I might regret not having chosen cobalt, which would give me shadow violets much more brilliant than those obtainable with Antwerp blue. On the other hand the brilliance of the greens given by cobalt and aureolin cannot compare with that of the aureolin-Antwerp blue combinations. A judicious mixture of all three gives various tints of brown and purple brown, while dark-madder and aureolin of course produce orange.

It would be no waste of time on the part of the beginner to spend a few hours with his colour-box and a sheet of paper, making a series of experiments in mixing, carefully noting in his mind the results of each mixture. He might proceed on the following lines:

Antwerp Blue with or without a touch of *Viridian* gives an intense greenish blue which I find very useful in sunlit skies.

Cobalt and *Dark-Madder* give violets suitable as partially complementary shadows to green.

Aureolin and *Dark-Madder* give oranges.

Aureolin and *Burnt Sienna* give richer oranges. There is no risk of dirtying in combining these last three colours.

Cobalt Blue and *Light Red* furnish very delicate greys, while from *Ultramarine* and *Light Red* we get greys slightly less refined, though more useful in, say, grey winter leafless-tree subjects in England, when painted in a scheme of burnt and raw sienna and low purples.

Aureolin and *Viridian* in varying proportions give us an exceedingly useful scale of transparent sunlit greens extending from bright yellow to slightly bluish green. These tints ally themselves very well to the cobalt and madder or mauve violets used as partially or completely complementary shadow colours. If interested in painting full sunlight effects you should make an exhaustive study of the oppositions of these greens and violets in the treatment of grass and foliage.

Aureolin and *Emerald Green* (*Vert Veronèse*) give the most brilliant sunlit green obtainable—unless a light cadmium in place of the aureolin would raise the brilliance a note or so.

Aureolin and *Antwerp Blue* give practically the same results as aureolin and viridian, and I should perhaps find it difficult to say why I myself generally use the latter combination, adding a little mineral blue to the viridian only when I want a still bluer green than the viridian itself gives. The second combination seems to give cleaner greens, but it may be only an idea.

Personally I never use the combination of *Aureolin* and *Ultramarine*, which seems to give rather a heavy result, though I can easily see where they may be used together. Such points must be decided by each painter for himself.

Cobalt and *Aureolin* give slightly opaque greens, useful in their place to render, for example, some of the endless varieties of green that one sees in overlooking fields containing different crops in spring; or they give certain grey sea greens.

Crimson Lake, which I have marked as a somewhat optional colour for landscape work, gives much the same results in its mixtures as madder; but richer, deeper, more intense, and less fitted to silvered schemes; which latter, let it be understood, are in no way antithetic to brilliant ones. For this reason it is possibly of less use out of doors, where colour, however rich it may be locally, is always silvered by light and air. It is a more economical colour than madder as it ' furnishes ' much more.

For English landscape the two *Hooker's Greens* are very useful. They may be lightened with *Aureolin*—or with gamboge; which may always be substituted for aureolin from motives of economy; though the results are slightly inferior. Hooker's greens are simply ready-made mixtures of Prussian blue and gamboge to save trouble, and to ensure great constancy of tint throughout a considerable painting. In the South, where greens are less rich and more silvered, they are less useful. I used to obtain very agreeable rich foliage tones by mixing Hooker's green with crimson lake or carmine.

Yellow Ochre and *Cobalt Blue* or *Ultramarine* give very agreeable grey greens of the willow foliage type in grey weather; or they may even be used in sunlight expression, if the suitable transposition of key be made throughout the work.

I have made no mention of such colours as Van Dyck brown. Most of the painters I know, if not all, have discarded it. It is true that certain agreeable greys may be

obtained by mixing it with cobalt or ultramarine blue. All the same I should prefer in every case those that come from the use of raw umber in a similar way; they are cooler, and more silvered. Also quite a sufficient series of greys arises from the burnt sienna–light red–blue compositions. Why then should we encumber the palette with scarcely useful tints? As for the use of sepia for monochrome sketching: the proposition can of course be upheld. Personally I prefer to mix a tint with, say, burnt sienna and ultramarine; for I have found that the almost unavoidable inequalities of colour, due to mixing, far from harming the aspect of a sketch, generally have the effect of enhancing its charm. But here of course we encroach on the territory of personal taste and opinion. Such points the sketcher must decide for himself after a little experimental practice. If his work is to possess any interest, it must be instinct with some results of personal points of view, of personal likes and dislikes, of deliberate personal decisions. In such matters as the list of colours he employs he may easily begin to exercise such personal judgement. The only advice I really give him is: Begin with as small a number of tints as possible; systematically study their combinations; add to them cautiously, and experiment anew. This will keep you from straggling haphazard over a complicated palette, mixing at random, and finally being in possession of no precise information.

I do not hesitate to counsel you to read many times and thoughtfully the letters of Van Gogh to Émile Bernard. They put us in direct contact with the ideas of an original colourist; ideas written down white-hot from communion with Nature herself and impregnated with the passion of his own desire. Convincing as can never be mere professorial study of the already done, Van Gogh's words tell us the story of art in the making.

IX

TECHNICAL HINTS

THE classic water-colour paper is Whatman or some allied kind. These unglazed papers possess many qualities and some disadvantages. If one intends to work up a drawing by means of repeated washes and takings out, they are indispensable; but for summary sketches I have taken more and more to using glazed papers, even ordinary notepaper or thin wrapping paper, on account of the greater ease that is afforded by the smooth surface of using a pen or pencil line of a delicate nature. In any case I think the heavy grained papers are to be avoided, especially for the small work that concerns us here; it is so very difficult to avoid a cotton-woolly result on them.

Tinted papers are of great help in rapid sketching; they supply in great measure the half-tints ready made; one works both ways on them, towards the lights and towards the darks; which is quicker and easier than proceeding from white paper in one direction only, towards the darks. It is obviously necessary to use white on tinted papers. The 'sugar paper' of David Cox is a good paper for low-toned rich-colour work; though a little more difficult to use than 'Turner grey' paper—blue grey—prepared specially for water-colour work. This latter is a very useful paper, allowing of considerable variation of key; on it Turner executed his Rivers of France, as well as a large number of other sketches; if you intend to use it a few visits to the National Collection of his water-colours will prove

a profitable source of technical hints. My only quarrel with it is that it seems to take pen-drawing with difficulty— I almost always use a fountain pen—that is, the pen fails to mark if rapidly and freely moved over the surface; a previous wetting of the paper, subsequently allowed to nearly dry, lessens this difficulty.

Unless you paint naturally very low in key, do not use the dark brown-grey papers generally sold at a high price by enterprising colour merchants. To do so is to voluntarily reduce the chances of a luminous success. Indeed, there is absolutely no need to buy expensive special papers. I have often used the thin cheap typewriting paper on which I am inscribing these words.

Directions for mounting and straining paper are rather beyond our limits. They may be found in any treatise on machine drawing; for the inconsiderable work proposed straining is unnecessary. If the artist prefers using strained paper, undoubtedly more comfortable to work on, he had better buy Whatman not-pressed (or hot-pressed) ready mounted on card. It is to be found at every colour merchant's. Whether to use a block or a sketch-book must be left to individual taste. One of the most agreeable sketchbooks I ever used was made to order in Rome. It was made of a thin semi-transparent wrapping paper, such as stationers and other tradesmen use for wrapping up small articles. The paper is very cheap, and, being thin, a great number of leaves only make up an inconsiderable weight. I was unable to find exactly the same paper in Paris, and was obliged to content myself with a yellower, more highly glazed one, which is far from being agreeable; moreover, on prolonged exposure to light it turns to a light brown. The latter tint is a very agreeable one, and has in some instances improved the effect of the sketches executed on

it; but it is possible that the change would not always be for the better. If one does use such very thin paper, it is unnecessary to wet it before painting.

Ingres or Michelet, either white or tinted—say the blue-grey note—is useful for making rather large sketches in Conté or carbon pencil, afterwards tinted with water-colour. I know one artist who produces delightful sketches on school arithmetic paper, blue squares and all; they are very slight pen-drawings in Indian ink diluted with water, which gives a grey line; which in turn is aided by delicate washes of colour.

The frontispiece of this volume was drawn on a very slightly glazed wrapping paper, bought at the local stationer's, of the kind used by him for wrapping up his goods. The sketch was rapidly drawn in with a fountain pen, and then painted directly with running colour, containing here and there a little white. When the first painting was finished, almost dry colour was broken into the still wet first washes in order to obtain the requisite darkness of the lower tones. The effect was a very fleeting one, so this was all that could be done.

For some reason that I have never been able to under-stand, amateurs seem to be averse to using a technique of combined colour and line. They almost always aim at a complete water-colour painting. Now as a matter of fact we can note much more information in less time by using the combination method; and note it in a way which demands less technical ability in managing the sometimes obstreperous material that is water-colour. We are in good company, for the great artists have never disdained the use of the double means, which enables us to lay up informa-tion concerning exact form (an operation impossible to any but very careful and tedious water-colour work), com-

bined with notes of the variations of colour and of value. Black Conté crayon or Wolff carbon may be used with advantage to make a drawing in which the shadows may be partly indicated by hatching or scribbling.[1] If a ' lead ' pencil is used for such combination work, an ordinary HB will generally be found to be the most useful. Always sharpen your pencil well, leaving a good length of lead free from wood, and the whole of the sharpened part in the form of a very acute-angled cone.

For a long time I employed a rapid pen-line in ink of tint suited to the key and colour harmony of the sketch. An advantage of this method, if ' water-proof ' inks are not used, is that the pen-line, in fast work, has not completely dried before the colour wash is passed over it. As a consequence, the line ' runs ' slightly here and there, so giving rise to passages and envelopments often very happy in effect. The frontispiece was painted in this way. Those who do not feel certain enough to commit themselves at once to a line in indelible ink may, of course, precede it by a light sketching-in in pencil. If there is time enough, it is always as well to sketch the drawing in lightly at first and then go over it a second time; we thus learn not only where the difficulties lie but how to avoid them, the final effort becomes less hesitating, more determined.

I prefer short $2\frac{1}{2}$-inch pencils, which I hold vertically to the surface of the paper and between my thumb and fingers, the short shaft of the pencil being inside my closed hand and directed towards the palm. The modern European way of holding pen or pencil in a direction inclined to the surface of the paper is a terrible barrier to the proper production of

[1] In spite of the advice I remember reading years ago in a manual on water-colour painting, in which pencil shading was strictly condemned. Of course very proper counsel if a finished transparent water-colour is in view.

a plastic line (by which is meant a line fitted with meaning rhythm and suggestive of third-dimension or volume modelling). The nations that have pushed expressive form to its highest limits have always used the point (generally that of a brush) held vertically to the paper. This position enables the point to travel with equal ease in every direction; and thus it produces a line whose width and nature are not dependent on the direction of the movement of the instrument, as is the case if this last be held inclined to the surface. Some artists get over this difficulty by holding the pencil almost horizontally, *inside* or under the palm of the hand, and continually turn it so that it always lies in a direction prolonging that for the moment followed by the line. But by this means it is impossible to obtain a line as plastically valuable as by the use of the vertically held tool. Egyptian painters held the brush horizontally in the supine hand, and in continuation of the forearm line; they drew, of course, on a vertical surface. The Greeks drew their inimitable vase paintings either with a brush held in the closed fist, as one would hold a dagger, or pressed against the inside of the three middle fingers by means of the thumb and little finger, the hand remaining almost completely open. The modern Chinese, both in writing and drawing, hold the brush in rather a complicated fashion, and strictly vertically. The wrist remains close to the paper, the hand is bent sharply backwards, the brush is firmly held between the thumb on one side, the last joint of the forefinger and the tips of the two middle fingers on the other; the back of the little finger presses against the lower part of the brush. This method enables them to produce the brush-line drawings which, for aesthetic intention, have never been surpassed. However, the difficulties in the way of seeing form are already

quite enough without compelling the unfortunate student
to hold his pencil in an unusual way, so we must resign
ourselves to the use of the ordinary writing position, only
regretting that we have not that artistic basis to our
national character which renders the school writing lesson
in China an advanced course in brush handling.

Unless a water-colour brush be used for drawing a line,
in which case it must inevitably be drawn along the paper
in differing directions, we must be careful not to ' paint '
with it as one does with an oil brush; liquid colour must
be led over the paper, sometimes brushed against the
boundary line, sometimes conducted along it by the point
of the brush held at right angles to the line of the drawing;
the heel of the brush will give an enveloped limit to the
wash, the point a decided and clear one. In practice
a wash surrounded on every side by equally sharp boun-
daries is generally of unpleasing effect; one side of it should
be gradated into the next tint. The choice of the direction
of this gradation must be made in observing the object
about to be represented. Sometimes it will be the light
side which passes insensibly into the background, equally
brilliant, while the shadow side produces sharp and deter-
mined accent; sometimes, on the contrary, the dark side
will conceal itself in mystery. The gradation of a small
wash may often be obtained by putting on the colour
fairly liquid, drying the brush on a rag or squeezing the
colour out with the fingers, then taking up the colour
again from the places in which it is superfluous. Where the
colour is left liquid a sharp edge will be formed on drying;
where the colour is but thin and dry the gradation made
in it will remain.

Smooth gradations on large expanses such as the sky
require some technical skill to achieve; you should damp,

or rather wet, the paper thoroughly before beginning; especially if the weather be hot. This prevents the colour from entering immovably into the pores of the paper and drying at once, before we have time to shift it. As a rule, incline your paper sufficiently; and, beginning at the top, let the quite liquid colour run down of its own accord, only leading it horizontally across the paper with the brush. The excess of colour may be taken up with a dry brush at the bottom. Less and less colour, more and more diluted with water, must be taken in the brush as we descend; for the normal sunlit sky is always darker at the zenith than at the horizon. One of the greatest difficulties the beginner experiences is to estimate the amount of liquid in his brush before applying it to the paper. With a very little practice the habit of estimation is acquired to such an extent that it becomes quite unconscious; and one catches oneself stopping, half-way from the palette to the paper, conscious in some occult way that there is too much or too little water in one's brush for the job in hand.

Always mix enough of every tone to cover the expanse of paper to be tinted with it. Re-mixing in the middle of a wash is almost certain to be attended by failure, both in exact reproduction of tint and in cleanness of wash. One cannot too often repeat to beginners: ' Do not be afraid of using too much water; nor of employing too big a brush.'

Accidental blots may be taken up with a nearly dry brush. But by far the best way, if the paper has not yet received a wash, is the impolite, but highly effective one, of licking them off. Corrections may be made on good water-colour paper, or even on cartridge, by washing out with clean water and a brush. You should not try to hurry matters, as by so doing you will only destroy the surface of the paper. If you are using cheap paper not intended for

water-colour, you will find it practically impossible to correct by washing out, and will be forced to use opaque body-colour; the use of which must be continued throughout the work in order not to produce inequalities of technique. On first-class paper, by use of a sponge we can take parts of a painting out completely; but the job is a long one, necessitating very careful joinings up to render it invisible, and such methods belong rather to painting in water-colours than to sketching technique; for it would generally take less time to begin the sketch all over again than to carry out a serious correction. In these latter days there seems to be a growing tendency to use water-colour in ways which utilize as well as possible its intrinsic qualities, I mean those of lightness, delicacy, and suggestiveness, combined with the advantage of rapid handling; the carefully worked-up water-colour, once the pride of the English school, has rather fallen from its vogue. I have always felt that the charm of water-colour lies in its delicacy and its immediateness. When worked up it becomes somewhat of a hybrid medium; incapable of the accurate value and colour study of oil paint, it has lost the suggestion and freedom of its first and simpler state.[1] All mediums have a best use which is natural to them; we should not attempt to make line drawings in charcoal, nor light and shade ones in lead pencil. But in sketching there is no question of the use of long and laborious ways of work, so we will return to the consideration of the immediate ones. A good method is to execute one's first painting on quite wet paper, letting the colour run where it will; then, as the sketch becomes covered, break into the still damp washes thick colour taken up from the palette with

[1] I am of course not speaking of either fresco or tempera painting, which have special qualities of their own.

the dry brush tip. While washes are thoroughly flowing we may do what we like with them, but as soon as they begin to dry we must be very careful to adjust exactly the quantity of water in the brush destined to touch them. If there be a drop too much in it the colour will fly in every direction, leaving an ugly white spot surrounded by an aureole of darker colour in the middle of what was a clean wash.[1] When a certain degree of dryness is reached, as this dryness is forcibly of an unequal intensity in different parts of the drawing, it is as well to stop for a minute or two and let the whole sketch dry completely; otherwise the different quantities of water in the paper will produce unhappy accidents when we put on our second washes; in one place the underneath colour will remain attached to the paper, in others it will come up and mingle with the new wash. These second washes are destined to give precision to the objects and value to the shadows; a skilful operator will finish his sketch in these two processes, though we shall often be obliged to return again and again with third and fourth and subsequent washes to complete our modelling.

Lights may be taken out of the first painting, when it is nearly dry, with a dry brush; afterwards they may be produced, in a moderate and gradated way, by washing with water and a brush; or they may be taken out in a brilliant and precisely drawn way, by first drawing the shape of the light with plain water on the sketch, leaving it a minute till nearly dry, taking off the superfluous water with blotting-paper or rag, and then quickly rubbing with india-

[1] If colour only, or colour and light and shade of a very enveloped and vague nature be desired, a good plan is to work all the time on soaking wet paper. This may be obtained by laying on a zinc or glass plate several thicknesses of wet blotting-paper, and on them the well-wetted drawing-paper, which will thus remain damp throughout the time taken for the sketch, and will thus absorb the colour evenly.

rubber or bread. Or of course the quicker and simpler method of painting them in with white may be adopted. The various different techniques used by veritable painters in water-colour cannot be discussed here; they are generally much too tedious to be employed by the sketcher.

Some people prefer not making a floating first painting at all; they begin at once on hardly damp paper (it is always best, except in cold damp weather, to wet the paper to begin with, otherwise it is very difficult to get fairly large masses of colour on at all evenly), and put in washes as precisely limited *taches* of colour. Of course the two methods may be combined in any proportions.

Though very agreeable effects may be obtained by the use, in places, of almost dry colour, the beginner would do well to avoid all temptation to try to get them. He may set up as a maxim that it is difficult to use too much water in water-colour painting. Almost all debutants' work is dry and disagreeable and papery, from lack of liquid flowing washes, and from the use of too small a brush. I should like to condemn all students to work, even on small work, with a brush whose ferrule measured at least ¼ inch in diameter. Indeed, if it be a good brush very fine work— quite fine enough for sketching—may be done with it. It is not the size of the brush that determines its usefulness for detail drawing, it is the fineness of its point. For this reason never buy a brush without testing the quality of the point by dipping it in water. On withdrawing it, the hairs should run together to a sharp point of their own accord, or at any rate with the smallest persuasion on a palette or by shaking rather forcibly. A brush whose point continually disappears in a shapeless end is the most annoying and useless tool one can imagine. To obtain this quality of automatic point formation it is not necessary to buy

expensive sables. I have often come across sables much inferior to many humble camel-hair brushes; so little, if at all superior, have I found sables to be that for the last ten or fifteen years not one has figured among my water-colour brushes, with the exception of a very fine long oil sable that I use for line-drawing in water-colours. Two or three good camel-hair brushes in metal ferrules are all that the sketcher needs. You may choose, for ordinary small sketches, a $\frac{1}{4}$-inch ferrule, a $\frac{1}{8}$-inch, and a $\frac{1}{16}$-inch without going far wrong. Eschew all such fantasies as: bits of sponge mounted on the end of a stick; expensive combined sketching apparatus; and all the enticing odds and ends that ingenious colour-merchants have invented for extracting money from the pocket of the unwary. Three camel-hair brushes, a bit of rag, a pen (either fountain or ordinary); a lead pencil (F or HB); a piece of good india-rubber; a colour-box or palette with half a dozen well-chosen colours; a leather case to hold the brushes; and a screw-top water bottle; constitute the whole of the material I would ever submit to carrying about for sketching purposes. To these must sometimes be added a folding sketching stool; and a parasol if you are to work in southern sun; for however little you may need it for your bodily comfort, you must have it to shade your paper; it is impossible to see the tints you are using, when dazzled by full sunlight. A light sketching easel is useful for work of more than ten inches in length. But here we are already touching the limits of our subject.

Hiscox, a clever and most prolific water-colour sketcher, used to work a great deal in Burnham Beeches; a sketch block, a pencil, and a colour-box formed his portable outfit. When he arrived at the place of his labours he fished an old and backless kitchen chair out of one bush, an

elementary easel formed of three narrow hinged planks out of another; re-discovered an empty mustard tin, which he hung with string from one of the two bits of stick that served as easel pegs, and set to work. The sketch finished, he demonstrated his joy by harpooning a thicket with the easel, where it remained in safe concealment till next wanted.

Sketching stools are generally fragile unsatisfactory articles. I solved the problem of their continual breaking once for all by having one made. It is of the three-stick type, made of hard wood; the legs were the work of a Chinese carpenter in Penang; the leather top, of thick pigskin, was made by a Florentine saddler. Every few years the stitches at the corners give way, and the local shoemaker sews them up again for twopence, otherwise it seems likely to last at least my life.

In old-fashioned manuals on water-colour painting, complete recipes were given for the confection of the different tints of the picture ; sky colour may be mixed in such a way, the distant mountain in another, the foreground trees in a third, and so on. This seems to me to be needlessly meretricious; needlessly to reduce painting to the level of mechanical drawing, where one tint represents steel, another stone, another brickwork; and, moreover, to throw unnecessary obstacles into the way of the most fascinating study, the observance of the ever-changing raiment of fair colour that clothes with added beauty the natural forms about us. If we always paint in one method and translate—as do so many professionals—into a fixed scheme of colour, we end by seeing nature through the veil of an acquired and *voulue* vision; her most delicate and evanescent beauties thus escape us. The professional may argue, and perhaps with reason, that, as it is so very

difficult to produce anything complete, he is obliged to specialize more or less in order to reduce the difficulties as much as possible; or that having a particular and decided artistic ideal to express, he chooses the colour scheme, the method of drawing adapted to that expression, and perfects it, casting aside all others. But the amateur should not consider his result in this way; a naïve noting of the beauty of a scene should be his object; his sketch should be looked on more as a means of drawing his attention to remarking successively secondary beauties that would escape the wide disorganized glance of an eye artistically inexperienced. You should be prepared to sacrifice your early work to learning to observe, instead of trying to produce an effective result as soon as possible by means of meretricious tricks.

For this reason, instead of giving fixed recipes, I have limited myself to describing, in the chapter *ad hoc*, the technique and colour mixtures actually employed in executing sketches. These means will be seen to have been different in almost every case. It must be the artist's task to choose each time the means fitted to the end; not only in the colour scheme, but also in the degree to which form, light and shade, or colour should respectively dominate.

All the same, I may mention in passing the old method of making first a careful pencil drawing in which the spaces occupied by the shadows are indicated, then filling in these shadows with bluish or purplish grey, and finally taking washes of colour over both shadow and light alike. This is what may be termed a safe method of obtaining a result; though its successes, such as those that Girtin knew so well how to obtain, are limited to breadth of chiaroscuro and dignity of effect. Transcriptions of evanescent beauty of colouring cannot be attempted by this method.

It may be that it is nevertheless an excellent schooling for the beginner, whom I advise to become familiar both with the simplification of shadow shapes and of their relative values, by doing a large number of exercises in the style of first paintings of the old method. If he care to, the student may easily carry them a step farther by tinting with thin transparent colour washes.

Perhaps no better advice could be given than to study often and carefully the landscape drawings of Claude Lorrain. An excellent collection is in the Print Room of the British Museum; and Gowans publish many of them in a volume of their art series. Questions of massing, of composition, of justifiable arrangement of accents, of solid modelling into the third dimension, of careful study of tree form are treated in these drawings with a masterly skill that has seldom been equalled in Europe.

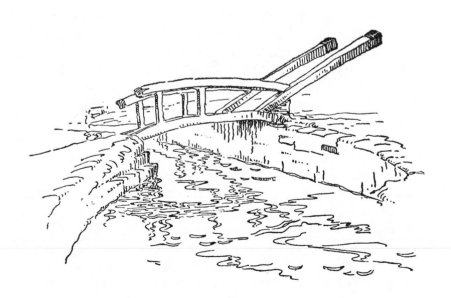

X

CONCERNING THE REPRODUCTIONS

§ 1. *Introductory*

IT has been thought fit to illustrate by means of reproductions of landscape sketches the various points brought forward in these pages. For this purpose I have selected examples from among the notations of some of the greatest of European painters, and one from the Far East. Each example has primarily been chosen to demonstrate some particular detail of execution; but it will easily be understood that, while showing with clearness the facts in question, the sketches, being masterly, may serve with nearly equal success to illustrate most, if not all, of the constituents of good work. Had each reproduction been fully examined at the moment of its presentation, an inevitable confusion would have marred the categoric development of the text. I have decided to consecrate this final chapter to a series of critical analyses of the sketches, each being treated separately and apart.

§ 2. *Boscastle. J. M. W. Turner* (facing p. 2)

It is interesting to compare the finished engraving of Boscastle with the first rough pencil sketch in which it found its origin. Next to the possibility of comparing the noting of a master with a photograph of the scene taken at the same moment, we have here one of the best ways of studying the choice of essential elements as Turner understood them. In the finished drawing one easily traces the stratification of the rocks sloping upwards from right to left in the right-hand headland. This upward trend is

felt throughout the left-hand side of the picture, though it is not quite so clearly marked, except in the actual sky-line. It should be noticed how the farther cliff in the centre of the picture is hastily jagged in the rapid pencil sketch so as to indicate in an exaggerated way the strata slope. The use of the line to limit the planes, which form the more or less horizontal top of the cliffs, from the vertical planes of the cliffs themselves is instructive ; as are also the half-dozen hurried strokes to indicate the curved flat wall top in the left front of the composition. In short, the lines of the pencil drawing play literally no other role than that of definitely limiting the important volumes of the subject. The only thing that interested the artist was the proper modelling of the great masses, the relief mapping of his future picture. No value statements, no envelopment, no 'impressionistic *taches*' are primarily noted by this greatest of all impressionists, this most fluid and aerial of all painters; *his* colour dreams were no baseless fabrics; however evanescent they were in seeming, they always had their birth in the fact of solid shape itself.

In the final picture he chose a lower view-point than in the sketch, thereby gaining in architectural stability and imposing height of hill. Also the line of the quay to the right is prolonged up the left sky-line, thus adding a stabilizing factor absent from the sketch. The top line of the same quay exactly continues the distant and now quite horizontal line of foam. These, and many others, are ' architectural ' improvements on the preliminary sketch.

§ 3. *A pen-and-wash drawing by Rembrandt*
(facing p. 16)

We have here a drawing, made with a quill or reed pen aided by wash, which is neither a very typical nor a very

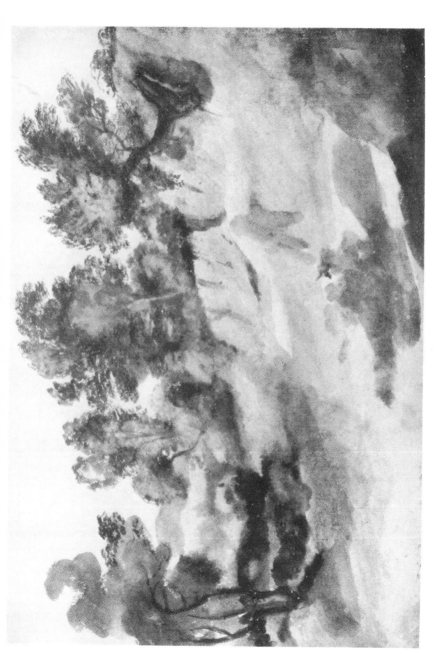

A SKETCH BY CLAUDE LORRAIN

British Museum

For analysis see p. 103

remarkable Rembrandt. The simple treatment of the reflections in comparatively still water led me to select it for reproduction. The artist has, of course, completely 'felt' the surface of the water, and has, so to speak, 'laid' upon it the oval scribbles of the tree reflections. Notice also his parsimonious use of vertical lines, which inefficient painters, as a rule, employ far too much, on account of negligence of the *fact* of the surface, and of too great an attachment to the *appearance* of the reflection. Indeed, Rembrandt, aware of the secondary importance of the verticals, has indicated even the few that he admits by secondary brush-work, not by primary pen drawing.

It is as well to remark, on the other hand, what precision he puts into his draughtsmanship in all that concerns the water. Most amateurs are inclined to float a little colour on well-wetted paper and to hope that vagueness will compensate for lack of careful noting. As I have already pointed out, the seeming vagueness of Turner is quite different, being based on a wonderful conception of the solid or liquid shapes.

Few painters have displayed a greater love of mystery— which might easily be confused with vagueness—than has Rembrandt; yet he carefully draws the reflection of the boat in uncompromising pen lines, just as carefully placed as those representing the solid woodwork of the boat itself. For all that, the water loses no whit of its liquidity; on the contrary it gains, because the drawing is a very exactly transcribed piece of study of natural effect.

Then again, the oval scribbles of the tree reflections are by no means as casual as may be thought; they are the rapid act of a highly trained brain in remarkable co-ordination with the executing hand. The scribbles lie, as

I suggested above, in proper perspective *on* the surface; and so doing they 'draw'—or suggest the existence of— the surface.

Rembrandt has carefully indicated the two tree-trunk reflections (just above the boat) and noted the darker one of the house shadow in a more broken technique of short lines which excellently suggests the disturbed state of the water after the passage of the boat. The disturbed state of the water on the left should be compared with the more tranquil tree reflection on the right; also should not be overlooked the lines of light—possibly caused by wind ruffling—which continue the line of the little landing-stage; they help to determine the surface of the water. It is because artists of the calibre of Rembrandt and Turner conceive and render with such accuracy the surface of water that they are able to dispense with the rigid distant line that inferior men fall back upon to help matters out. Perhaps I have said enough to draw attention to the real amount of observation and selection that a great artist manages to compress into the shorthand of a sketch, and to the way in which he contrives to reproduce the results of his study in such an unobtrusive way that the superficial observer fails to notice their existence at all.

But besides the treatment of the water this drawing is otherwise instructive. The main reason for the being of the sketch is evidently the group of trees and the house; these, with a portrait painter's habit and as a result of his own special aesthetic of centralized chiaroscuro, Rembrandt places centrally (the less central compositional placing of a series of Claude drawings might be advantageously compared). On these trees the interest must be fixed, so our artist details them far beyond anything else; far beyond the boat in the foreground, still farther beyond

the nearer bank in the left-hand corner; though neither
in one case nor in the other are the main facts of the model-
ling slurred over. In the group of trees Rembrandt has
carefully distinguished the different species; he has also
modelled the foliage masses with great care. Go over them
carefully; try to find a single place in which he fails to give
you a full account of the shape of the tree. Could you not
model a full relief in clay from the information he gives
you? It is in such precise statement that a second-rate
artist—shall we say Peter de Wint?—fails.

At the same time we may note with profit the very
perfect topographical presentation of the two little bits of
distance; on the left the exact surface shape of the ground
as it rises under the willow trees towards the houses is indi-
cated with, again, what parsimony of line! Then we can
count the rows of trees back to the church. Fix your
attention on this square inch of paper and then deny that
you could almost find your way about that bit of the
village conjured up by how few lines. There is not one too
many; even a line or two more would militate against the
suggestion of intervening light and air. The whole of this
unobtrusive corner of distance is as carefully thought out
as any part of the sketch; there is only a greater simplicity
of expression. On the right the line of trees runs back,
at forty-five degrees to the plane of the picture, till it meets
the house roof at right angles with it. Again all the state-
ments are exactly made, as they always are, by great artists.

§ 4. *A sketch by Corot* (facing p. 28)

The reader may well ask why I have introduced a
reproduction which does not obviously illustrate either
of the two points which have occasioned my mention of

Corot in the text. As a matter of fact the tendency of Corot to use an important tree motive on one side, and to balance it by means of a far more exiguous group or stem on the opposite side of a compositional centre—in this case the dark accent over the house roof—is quite evident, when we notice the equilibrium is arranged along the diagonal of the picture (right bottom corner to left top) instead of along a horizontal line. One might liken this equilibrium to one in which the beam of a balance comes to rest in an inclined position.

But this reproduction may serve a very instructive purpose. Undoubtedly, Corot was a great painter; however—there is no denying it—he must be content to take up a secondary position when compared with the greatest, with Rembrandt, with Poussin, with many others. It will be instructive to try to find out just whence this slight inefficiency springs.

It is rather beyond the scope of this practical book to deal with abstract artistic intention, but I must here at least touch on the nature of Corot's aesthetic success, for this same success lies far more in the quality of his emotion than in the technical rendering of it. The reason of the inferiority of his work when it is compared with that of other and greater men is to be found probably both in the frailty of the theme itself and in certain weaknesses in its technical statement; if indeed these two are really distinct one from the other.

The emotion of Corot is a very charming, a very fragile thing, quite unmixedly French. It is light even to flimsiness. Corot faintly tinged his work with melancholy, but with such a tenuous touch that its sadness is almost spirited away once more by a fair round of maidens dancing, careless, by the border of a lake in May. It

is to the seduction of this exquisite dreaming that we succumb.

What part is played by inefficient technical treatment in the rendering of this particular theme? The discussion in detail of such a subtle problem in aesthetics would take us far afield; in general we should call attention to the way in which almost the whole of Corot's art is already enclosed, two hundred years before, within the *Paysage avec St. Jérôme*, by Le Poussin, now in the Prado Museum, Madrid. But without treating of the aesthetic significance of certain technical waverings we may remain within the territory of a practical book while pointing them out.

The tree trunks on the right are fairly well ' thought ' into the third dimension, though conception of the larger trunk remains a little undecided. The weak scribblings on their surfaces destroy, instead of aiding, the illusion of the roundness. No great master, nor even the incomplete Cézanne, would be guilty of such carelessness. Then look at the small trees on the cliff-top; they are seen quite flatly; we have positively no information given to us concerning their shape in the depth of the picture. Examine for a moment the diagonal plane that, in front of the house, runs part way up the cliff. How much it too lacks in modelling! *Not* on account of its unfinished state, but because the artist had not himself definitely conceived its shape, and thus did not properly choose the elements of its limiting boundaries—mainly the shadow edge on the nearer, and the four or five rather carelessly drawn lines on the farther side. Compare this want of precise study with, say, the exactitude of the Rembrandt statements above. The whole mass of the overhead cliff is doubtful and hesitating in modelling; how very different would be the exact suggestion of its shape in Turner's most hurried

scribble! The rock is evidently sedimentary, probably a sandstone, but though one can see that the stratification is approximately horizontal, one is hard put to it to state its exact lie. A most casual glance reveals the flatness of the goat, especially at its shoulder; again the artist had no clear conception of what should be happening to the form. Then I cannot prevent myself from feeling uncomfortable about the placing of the man and goat. I will not take upon myself to suggest a change; but I ought not to be made to feel even that a change might be necessary. One of the unfailing tests—perhaps the only one—of genius is that it should leave us wondering at the perfection of its effort.

Still there is much positive instruction to be taken from this sketch, which, though it may be excluded from the august company of the fully triumphant, yet is far above that of the many in its worth. Even its defects may be almost copied by the amateur, who cannot hope, himself, to tread the higher fields of great election. Should he try to copy the fine free certainty of complete knowledge, his certainty will become tightness, the incompleteness of his knowledge will but become more patent. So perhaps from the looseness of this drawing he may learn with profit how far one may go by means of slight free scribblings and broadly massed simplicity of shade and light. The tint of the paper, the dark accents, and at most two intermediate values are all Corot employs. The sky and the uninterrupted L of light on the ground are uncut by value variations within themselves. The half-tone groups are only two: the two tree trunks and all the foreground; the cliff and small tree group. On this pair grouping of two values is superposed a decorative pattern of dark lines and accents. And that is all. If the smaller tree

group be inadequate in volume rendering, note with what gay lightness of intention the lines seem to spring and dance upwards; a gaiety of line everywhere seems at one and the same time both to crave our pardon for its heedlessness and furnish a just counterpoise to an inherent sadness of reverie. If your touch cannot rival the perfect notation of genius, let it be light and free. Like Corot, choose carefully your value arrangement, choose as carefully your line and accent arabesque; and, once your choice is made, execute gaily, almost heedlessly; a well-chosen scrawl is far more pregnant with meaning than is the result of ill-chosen application.

§ 5. *A late Venetian sketch by Turner* (facing p. 36)

This very late Turnerian vision of the Dogana at Venice I have chiefly chosen on account of the seeming imprecision of its means. The careless observer might easily suppose that form was indifferent to such a rapid cross-hatcher of tint, to such a worshipper of radiant light. Yet only a mastery of conception of the fact of receding plane will force the sea to stretch infinitely back beyond the distant line of boats, will make its surface reach forward to the foreground line despite the black accent on the left (see page 32). Veiled though they be in light and uncertain air the facts of modelling are never forgotten by Turner. It is this unerring comprehension of topographic fact that allows him to distribute as he may wish the fewer and fewer accents that finally composed his pictures. The group of boats, the exactly placed sphere of the Dogana, nearly make up this sketch. The rising sterns of the boats point almost directly to the sphere. Half-way along the imaginary line another faint accent breaks the distance. The thing is naught but a graded scheme of fairest tints.

How amazingly simple seem the means! Yet what massed knowledge underlies this mastering of tint, and of accent decoratively used.

§ 6. *A painting by Renoir* (facing p. 44)

The Renoir reproduced was painted in 1875. It is, of course, an oil painting. The reader should remember that the title of this book is not ' The Way to Sketch in Water-Colours ', but simply ' The Way to Sketch '. Why have I chosen the shorter of the two titles? In order to be able to insist more fully upon the underlying thesis of these pages, namely, that it is of very minor importance whether an artist employ oil, water-colour, charcoal, or any other medium he may like. The important differentiation between artists is not determined by the different media they may employ, but by their differing methods of looking at nature. Puvis de Chavannes is as much himself in a water-colour sketch as he is in his more usual oil painting. The same may be said of Turner, of Constable, and of any other artist.

I have mentioned Monet several times in the foregoing pages. Renoir is an impressionist of the same epoch. Not only does the present reproduction illustrate the tenets of the school just as well as would do a Monet, but it brings with it the added advantage of being by an artist who was at the same time a master of clearly defined formal drawing. Indeed, the greater part of his work is nude figure. But he lived and painted during the epoch of the impressionist reaction against meretricious tidiness unbased on fundamental knowledge. He thus somewhat put aside his highly trained capacity for precision, which hardly transpires in the present reproduction elsewhere than in the remarkable truth of movement in the horse, and adopted

the confused and instantaneous notation of momentary impressionistic rendering of transient light and air.

The picture is especially instructive in demonstrating how little accurate brush-work is necessary, provided the artist choose the pictorial facts of the scene in their necessary order. When once we have 'understood' this order of relative importance of the various elements which go to make up the composition—the values, the colour, the solidity, and so on, of the subject—we can note them down as carelessly as we please, and the result will always possess a certain worth. I repeat that it is not the way in which the brush or other instrument is used that constitutes the validity or worthlessness of a work of art, but the way in which the artist has thought about the work.

One whole side of the artistic worth of such a picture cannot even be seen in the reproduction. I allude to the personal and intention-filled scheme of colour. However, the arrangement of the points of interest is evident. Notice the curve passing through the feet of the foreground groups, the horse's fore-foot, the patch of light at the left curbstone, the fragment of branch half-way up the left side of the picture. The same curve may easily be traced on the right-hand side. This curve is agreeably cut by the sweeping edge of the foreground shadow. The straight lines, both vertical and sloping, of the tree-tops and buildings stiffen up the composition. The lower line of the right-hand row of trees points exactly to the left-hand bottom corner below the seated figure. The base line of the carriage, if prolonged, arrives at the signature corner and stretches back to the central point of balance of the composition, to which many other lines may be found to lead, and about which the dark masses may be felt to be in equilibrium.

§ 7. *A drawing by Paul Cézanne* (facing p. 45)

The drawing by Cézanne may with profit be compared with the painting by Renoir. I have chosen a very slight and not particularly attractive sketch the better to demonstrate the main facts on which Cézanne seized. First, note the determined cylindricity of the tree trunks, otherwise scarcely indicated; then, the sense of modelling in the foreground, though it practically remains white paper; also, the horizontality of the water, which lies just the right depth below the land. The cause of these successes lies first in the complete comprehension of the topographic facts; then in the apprehension of the elements of the appearance of the scene which are more especially due to them. The slight modelling of the land just along the water's edge, carried out as it is with exceeding care, is enough to suggest the modelling of all the rest of the ground. The tree trunks, of course, enter the ground at their very precise relative perspective places. Indeed, the most remarkable part of Cézanne's drawings is the minute care that he brings to such necessary indicating of shape, while he leaves, with unhesitating discrimination, all secondary statement a blank. Such drawings as this are exceedingly useful to the student, for they clearly show what one might term the underlying skeleton of the business. Notice also the parsimonious way in which Cézanne has indicated the main modelling of the foliage masses. As always the drawing and composition unite to give a remarkable feeling of stability, in striking contrast with the Renoir, where movement, evanescence, and light effect are represented by a hasty and imprecise technique. It must be left to the student to decide which, if either, of the two schools he chooses to follow. But let

him not be deluded into thinking one easier than the other; success in either is based on true comprehension of the essentials of the scene before him. The casual technique of Renoir will degenerate into an unmeaning muddle unless it be based on thorough understanding.

'The value and rank of every art is in proportion to the mental labour employed in it, or the mental pleasure produced by it.' So spake Sir Joshua Reynolds in 1771. This drawing by Cézanne may be described as being the highly concentrated notation of the result of the application to the subject before him of the conclusions derived from long and careful study and reflection.

I might add that the trend of modern art is away from the ideal of Monet and Renoir towards that of Cézanne.

§ 8. *A sketch by Claude Lorrain* (facing p. 90)

This reproduction of one of the Claude sepia drawings in the British Museum was primarily chosen to indicate that the strong accents of the trees do not bring them forward in front of the pale unfinished foreground (see page 33). A full comprehension of the ground and other modelling keeps everything in its right perspective plane in spite of the incomplete statement of the nearer masses. The incompleteness of the statement matters not at all, always provided the artist has carried out the thought processes which would enable him, were it necessary, to make a complete statement. Omission must always be the result of judgement, not of ignorance.

At the same time the sketch being unfinished affords us a lesson in technical method. It is a brush and sepia drawing. The unfinished tree on the extreme left shows us the first massing in gradated wash. It should be noticed that the main modelling is already indicated in practically two

simple values; the way of dotting and almost ' writing ' in the foliage on the top of the modelling values is also clearly shown; it brings precision to the first value areas by following with insistence their limits already indicated. The curved radiation of the branch and twig forms that make up each bough is also handled in a masterly way by the artist, who never treats a bough flatly, but always as a perspective view of a solid body somewhat partaking of the shape of a supine hand, of which the thumb and fingers are all separated and curved as they would be to hold an orange.

It should also be noticed how well the three tree stems on the extreme left keep their respective distances and recede *under* the foliage. All this topography was perfectly understood before being indicated in so summary a way.

The simple way in which the shadow washes in the foreground are made to model it should be carefully studied. They justify the statements made on pages 13 and 32.

The main line of the composition (not, of course, a very good one) runs upwards diagonally across the paper from left to right. So does the secondary line of form and shadow in the right-hand foreground. To balance this sameness of direction and to retain the eye within the field of the picture, two lines more or less at right angles to the first pair are suggested. On the right-hand side a line runs down between the middle and right tree clumps and finishes on the top of the foreground shadow area. Another nearly parallel to it limits the right-hand side of the left tree group and terminates at the left extremity of the foreground shadow.

The three principal darks—(*a*) under the left-hand tree group; (*b*) under the central tree group; (*c*) under the

right-hand tree—imperiously call for the lowest foreground
dark to balance them. In spite of the unfinished state of the
picture, Claude felt himself obliged to introduce this dark.

The variation in technical treatment of the different
species of trees should be noted.

§ 9. *Landscape by Sesshū* (1420–1506), *Japan*
(facing p. 106)

On page 81 I have called attention to the way in which
Chinese (and of course Japanese) artists hold the brush.
But there I have let it be supposed that the only advantage
to be gained from such a method is the one of drawing
a line which shall be variable in quality at will, and shall
be free from any servitude imposed upon it by the direction
in which it is drawn. This, however, is only one of the
benefits due to the vertical holding of the brush.

A Chinese or Japanese character cannot be written
properly without attention being paid to the way of form-
ing each individual stroke, which stroke often consists of
three separate movements, although the brush does not
quit the paper while making them. A stroke is thinned or
thickened at will according to the degree of pressure the
writer brings to bear on the brush. He either uses the fine
point, or squashes the brush down on the paper. When
we write we only consider horizontal movements of the
hand; the Far Eastern writer also considers the motion of
his hand to and from the surface of the paper. As the
writer so the artist; for the relation between calligraphy
and painting is much closer there than here. This govern-
ing of the tool in the third dimension vastly widens its
range of expressive power.

From Monet and Renoir we have already passed to
Cézanne, and Cézanne is the key to the greater part of

modern art. Now whoever compares the drawing by Cézanne (facing p. 45) with the painting by the Japanese master, Sesshū, of four centuries earlier, will not fail to see the technical relation between them, though Cézanne is greatly inferior in skill to his Japanese predecessor. These, then, are the considerations which lead me to feel that I cannot close my counsels in a more fitting way than by a discussion of the technique of this sample of Far Eastern art. The philosophy and the abstract aesthetic thence bodied forth lie without our scope.

The compositional arrangement is by far the most important factor of the painting, as indeed it is in all plastic art; but here one may almost say that each brush-mark takes up its suggestive significance from the position it occupies in the whole decorative pattern. The types of brush-mark fitted to the representation of different objects, and the ways of combining them to that end, are strictly classified in China and Japan in a way that would put the careful recipes of our own forefathers of a century ago completely in the shade. The apparent carelessness of such a painting as this is founded both on tradition and on the severest training.

In this transcription of an aesthetic aim the wash plays but a minor part; as it does in the water-colour drawings of Cézanne. It is replaced by a graphic handling, nervous in character, pregnant with meaning. Look at the dry draggings of the brush over the foreground rock-forms; see how they at once suggest both shape and substance-quality of the stone. You do not think much of the thing? Try to imitate it, just to prove how easy it is to do. It is curious, not how difficult, but how impossible it is. The obsession of the transparent wash has done much to restrict the field of English water-colour expression; it is a pity. There is a particular joy in the various handling

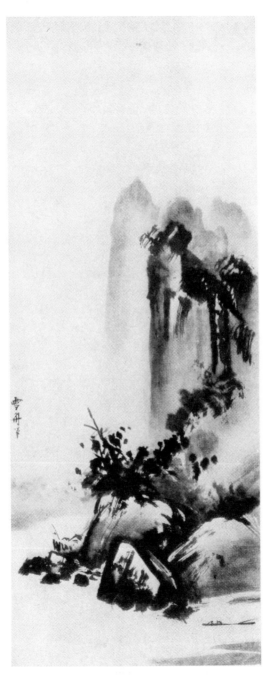

A JAPANESE PAINTING BY SESSHŪ (1420–1506)

From *Masterpieces selected from the Fine Arts of the East*

of the brush that Far Eastern schools do not forgo. In the present instance the statement of the landscape is reduced, wilfully, to its simplest form; and then the artist uses up every possible suggestive variation lying within his self-imposed limits. Several forms of brush are employed; so that on each occasion exactly the quality desired can be obtained.

As in this chapter I have decided to free my advice from the *credo* of the transparent wash, I will admit that I by no means limit myself to the use of one type of brush nor to using it in one way, as I recommended on pages 82 and 83. Indeed, a large part of my sketching is done on tinted paper with square oil hog tools. They are extremely useful for indicating the solidity of form in the way in which Cézanne indicated it; a way that has been afterwards hypertrophied by the cubists. One draws—with pencil or brush—the contour of the object; then, applying the brush, containing but little colour, to the contour, one drags the brush away from the line towards the interior and lighter part of the modelling. This produces a die-away gradation in the intensity of the tint, which is most effective in the rapid suggestion of more or less cylindrical form. But in this and other matters connected with brush technique the sketcher cannot do better than study atten-tively as many Chinese and Japanese examples as he or she can lay hands on. Some of the work is marvellously dexterous and the despair of Europeans. I have in mind a beautiful Chinese drawing of a bamboo shoot in which each leaf is completely drawn in one single stroke of the brush. Do you realize what complete mastery over the tool and what complete preliminary decision this necessi-tates, before one can draw two different wash limits at the same time, one with each side of the brush? The European would content himself with a simple pointed stroke, or

would be obliged to return several times to the matter, treating separately the various rendered facts.

Note amongst other things the vertical cliff in the middle distance of the accompanying plate. There is an underlying graded wash of grey. This establishes the modelling. Over the wash—of which the edge is used to draw, *in part*, the profile—the darker accents are nervously worked, in such a way as to complete the modelling already suggested. The upper part of the profile is insisted upon anew, thus giving a varied gradation of value along its length. Notice also in the apparently simple tint of the farther mountain the exceedingly subtle vertical indications of form. None of the apparent hazard is in reality due to chance. Need I point out the monument-like stability of the composition, the vertical terms of which rise perpendicularly from the mass of boulders at the base? The too great simplicity of this underlying idea is adorned by the variegated arabesque of brush-work that zigzags up the main mass.

But I must not allow myself to be led on to a discussion of the aims and techniques of extreme Eastern and of modern art, however seductive may be the theme. So let me end these words of advice with the most important of them all: Never forget that a sketch is first and foremost the transcription of a mood, of an emotion of the artist, and that, *ceteris paribus*, the value of his work will be in direct proportion to the completeness, to the genuineness, to the intensity of his emotion. Sketching consists, first, in analysing the cause of the emotion into its component elements; then in determining their relative importance among themselves, with a view to stating them in that order. A sketch is a statement of emotion. If you have no emotion to state, your sketch has no reason for existence.

XI

THE TREND OF MODERN PAINTING

A SKETCHER, even he who sketches simply and only for his own amusement, is necessarily influenced by the art movement of his time; in 1929 he will not sketch as he would have done in 1829. It will not, perhaps, be useless to close this book in its new edition with a short account of the movement of modern art, a movement that is, I have noticed, not at all often understood in its general lines of progression.

Exactly a hundred years ago the most potent factor in moulding the art of Europe was the British landscape school, especially as exemplified by Turner and Constable, who carried on and extended the Gainsborough and Crome tradition. This tradition brought the necessary revivifying touch to lingering artificialities of the last outcome of the Italian Renaissance and its baroque and pseudo-classic off-spring.

In 1830 Europe was at the height of the Romantic movement, which had a literary rather than a plastic origin. France, always greater lover of the artificial than of the natural, produced, as revolt against recognized painting, the *fougue* and improbability of Delacroix. But as the natural movement gained in force, this gave place to the ideals of Corot and of Millet, neither of whom could have done without his lesson from Constable.

Even before Millet and Corot, had definitely demon-

strated that theirs was the true handing on of the torch, another group was proclaiming a yet newer credo. Manet, Monet, and Sisley were preaching Impressionism.

History in the making never arranges itself comfortably in view of the historian's task. Movements always display a disconcerting wish to overlap one another. Impressionism was a revolt from the same artificiality which had displeased Barbizon. But while acknowledging a descent from Corot, the new group went back to certain earlier techniques of Turner and of Constable, especially in divisionism of touch with view to vibratory light effect. Still a wide gulf separates the ideal of Turner from that of Monet. Turner, despite his untiring study of nature, was essentially a composer, he created decorative arrangements of light and shade pattern, of design of varied tint. Impressionism prided itself on cutting slices directly from nature. Rendering of effect was the first aim. Appearance rather than reality was for it first and foremost, though this is slightly less exact of Manet. Shape was to a great degree eliminated.

Every excess calls for a back-swing of the pendulum. Even from the earliest days of impressionism, one by name Cézanne called out, somewhat inarticulately it is true, against this wholesale destruction of form. History here greatly overlaps. Cézanne had no business to be thus preaching in the early 'seventies. The Impressionists still had to have their success, which, thanks in chief to Durand-Ruel, they achieved during the last decade or so of the century. In England, as usual, they were recognized later. I remember asking for news of them in a London gallery in about 1905, and being shown, with an amused smile, a big Corot as a nearest approach to what was evidently folly. At the same moment I tried to persuade another gallery

to hold an exhibition of what were subsequently called 'Post-Impressionists'. I failed miserably in the attempt. A few years later the historic show at the Grafton Gallery took place. The *Morning Post* published columns of letters which demonstrated once more to what degree ignorance is the best qualification for writing, or at least for appearing in print. I wrote a short explanatory letter from Paris concerning the movement with which I had been from the beginning in close contact. The letter was, of course, not inserted.

I, too, am allowing myself to advance too quickly in this account. What had been happening in England since the close of the vital period of Turner and Constable? The English water-colour school had been invented, but had, during half a century, gradually drifted away from the sincerity of its founders and lost itself in the intricacies of technique for its own sake, of manual dexterity. Pre-Raphaelitism died without influence, save in that Morris instituted the modern school of decoration. Vitality in art had recrossed the channel. The abortive attempt to create an 'Indépendants' in England is alone proof of this. From 'Les Indépendants' in Paris all modern painting, impressionism included, has taken its start.

Suddenly, after a slumbrous appreciation of smart water-colours or of staid academy pictures, were thrust upon England in far too swift succession, Barbizon, Impressionism, Matisse, Van Gogh, Rodin, Cézanne; and before she had time to get her breath again, Cubism, Futurism, and whatnot came crashing down upon her. Fifty years of pretty rapid progress crowded into a decade, and often in the wrong order at that! I think I am right in saying that Matisse, and perhaps even Picasso, preceeded Van Gogh, who died in 1887! Little wonder if many are confused by

this cataract after the long and peaceful stretch of nineteenth-century years scarcely ruffled by Whistlerian wit.

Soon after the Impressionist movement had been definitely accepted among the leaders of the Paris art world began divergence of direction. None of the modern movements has been endowed with long life as judged by former standards. Why? Because if each credo contains a parcel of the truth, none contains it in its totality, nor in sufficient quantity to make of a picture an enduring work of art. Hence each doctrine stimulates opposition which would oppose to part truth another part truth in verity equally valuable.

A mild protest against the 'carelessness' of the impressionist brush-mark was *La Grande Jatte* de Seurat, a mechanization of divisionism. But unbased on true formal fact the thing terminated in a blind-alley.

However the indications of direction for the twentieth century were already issued before—shall we say?—1885. They were double. In matter of date Cézanne's doctrine preceded Van Gogh's, but Van Gogh exerted his influence before his predecessor, though only after his own death. Let us follow the history of influence rather than that of inception.

Monet and Sisley made use of the vivid palette invented by Turner, but they used it in order to practise imitation. Van Gogh perceived that imitation, even of effect only, is not the end of art. He had perceived certain essentials of the Japanese point of view: that art, if based upon nature, is, or should be, primarily decorative and creative. In this short study an aesthetic examination of what decoration may be or signify cannot find place; the word must pass for the moment. Van Gogh used brilliant colour

in a decorative fashion for the first time. I must make one
necessary explanation however, here. By the decorative
use of colour I mean to imply a decorative quality in the
nature of the tints themselves. I do not mean a satisfactory
tinting of a design destined to decorate a wall or other
object, I do not mean decoration like to that of a Florentine
fresco. Van Gogh was 'decorative' naturally. I think
he scarcely realized the fact himself. He believed himself
to be a nature worshipper. But the god he really adored
was the decorative possibilities of nature. His art was
unconscious, was not preceded by a printed and explanatory
manifesto, hence the value of his work. There is little
theory and much practice about Van Gogh. Glance at
the amazing invention of different forms of pen-mark in
his drawings, and how each type takes a decorative place
in the whole.

This unexpressed doctrine—unexpressed in words—of
decoratively invented and arranged colour was seized upon
by Henri-Matisse, and by him, so to speak, anatomized,
schematized. He abandoned, in 1900 and the following
years, the aspect of nature; he dealt in mere arabesques of
tint, formless, artificial. He exaggerated, with full know-
ledge of what he was doing, what Van Gogh had done in
part and unconsciously. We have now entered fully upon
the period of 'doctrines' that Impressionism had inaugur-
ated forty years before. Once celebrated, Matisse passed
on to a style of fuller painting more based on natural
observation. We can still trace in it his particular gift of
colour invention. Many times has he compelled my
admiration by some unforeseen juxtaposition of tint which
suddenly enhances colour value. Yet to his more completed
painting I cannot accord that praise which I am ready to

lavish on Van Gogh. Probably to appreciate both of these artists one must, oneself, have attempted and carried to some distance invention and management of colour. To them and to all the moderns we may address the reproach that their work is scarcely more than a professional exercise, an attack made upon part only of the problem, a dissection of the matter fit only to arouse full interest in another skilled professional.

While one branch of development was thus extending almost to the present day, another, that of Cézanne, at the beginning contemporaneous with the impressionistic movement, marked time, was only practised by the high priest himself. Things were not ripe for the doctrine of Cézanne until the first ten years of the twentieth century had passed away. What was this doctrine? First, to Cézanne the flouting of solid form by the Impressionists was anathema. To him the universe was a solid and durable concern, not an affair woven of ever-changing effect. A balanced arrangement of volume on his canvas was all he aimed at; he literally thought he could construct nature anew by sheer exactitude of copying. This is, of course, impossible. Hence his failure.

Art being an illusion is necessarily false in its methods. The most sincere among us is forced to employ certain tricks of the trade. Cézanne was an example of considerable gift spoilt by incomplete reasoning.

From Cézanne's teaching of the geometrical simplicity of essential form arose, with the aid of Picasso's ingenuity, Cubism, a name due to Henri-Matisse. It flourished between, say, 1911 and 1918. It afforded the extreme pendulum swing away from photographic art. The vision of nature was to produce in the artist's mind the idea of a

pattern of abstract shapes, which should rather indicate to us the effect of nature on the mind of the artist than the way in which nature was apparent to him. The terms 'dynamism', 'synthesis', 'organic structure' now began to enter into the aesthetic vocabulary and were used in vaguely wondrous ways.

Critics and public had made so many mistakes since the historic error about the Impressionists that both rushed, in company with some painters, to the opposite extreme. Those who would be at any cost 'advanced' vied with one another in execution and in admiration of the most impossible. Futurism, Expressionism, Dadaism, and I know not what had meagre months of success round 1920.

But the Cubists were already executing a strategic retreat; they were announcing that Cubism had only been advocated as a means of studying aesthetic draughtsmanship, that it was now to be abandoned in favour of more normal drawing, but of a drawing instinct with the doctrine of the former faith. Indeed the recent tendency towards solidity in draughtsmanship is undoubtedly due in great measure to these exaggerations of Cubism which are now being brought back to reasonable practice.

The line of development of art during the first quarter of this century has thus followed two directions: On the one hand colour divorced from merely naturalistic aims proceeded on a 'decorative', on an 'abstract' way; on the other the nature of form and its effect on the artistic personality was, or was supposed to be, investigated. Colour in this research was reduced to negative browns and greys.

For this splitting up of the picture into component parts, at least in its most pronounced manifestation, I believe Matisse was largely responsible. Anyhow I remember his

saying, in 1900 at Carrière's, that he was trying to paint the violin part of a complete orchestration, or more exactly he held that it was quite possible to do so. The trouble was that some grain of truth was mingled with all the chaff of this amazing period. In reality, after a bad attack of purely photographic art, Europe was, and still is, waking to the fact, patent in China tens of centuries ago, that art is not imitation, but creation, creation of rhythmic schemes based on, but not imitated from, nature, schemes invented by the human mind.

In countries such as England and Germany it is not fully realized that the French people are much too matter of fact to have taken seriously the greater part of this unmeasured folly. These various '-isms' have been staged as an attraction for foreigners as are the cabarets of Montmartre. *L'art méteque* (art of foreigners who have taken up residence in the country) is the term which designates it in France. Still the history of art can no longer be written without at least an allusion to such anarchy. From it is gradually springing a latest doctrine of painting for painting's sake once more. But in this re-edition of an old cry count is taken of the immediate past, we have seen Cubism, we have seen decorative intention, we have read of the ideals of the Far East, we have learnt that art is a form of creation. The disjunctive efforts of recent years are fusing to a new renaissance.

What may be the role of English art in the coming years? In spite of a certain readmission of a limited quantity of emotion into the direct transference of visual impression from nature to expressive medium, I am almost tempted to fear that the restraints imposed by the new ideals upon free emotive expression will have their usual unfortunate

effect in England of producing an excellently 'well done' but uninspired technique.

For the moment English picture dealers seem to think that by pinning their faith to monochrome drawings they are showing themselves to be up to date. Again the eternal mistake, the confusion between the 'way in which it is done' with the underlying aesthetic motive force; the innocent satisfaction with the superficial aspect of the thing, refuge of those incapable of appreciating deeper significance. As though a monochrome drawing by Turner were not just as much a product of his aesthetic as is the most brilliant of his pyrotechnic displays. A reason for this imposition of the untinted is not hard to find. *N'est pas coloriste qui veut*—is not colourist who wills. Many more are capable of working in monochrome than in true colour. Thirty or forty years ago there was a sale for the pretty water-colour in bright tints lacking in significance and real harmony. The public has been educated beyond this by the numberless writings upon art which did not exist formerly. But to execute a modern picture in colour, a picture in which it is no longer possible to hide the inefficiencies beneath multiplication of detail or by pretty trick is another affair. Could the dealers fill their galleries to-day with full coloured pictures which would pass muster?

INDEX

Accents, 30, 32, 96, 98, 99, 100, 103, 108.
Alizarine, 71.
Arches in perspective, 10.
Arrangement, decorative, 27.
Aureolin, 58, 69, 70, 74, 75.

Balance, 29–30, 101, 105.
Barbizon, 110, 111.
Baroque, 109.
Black and White, 44.
Black mirror, 39–40.
Blots, 83.
Blue, Antwerp, 51, 58, 69, 70.
— Prussian, 51, 69.
Branches, 22–4, 104.
Brilliance of colour, 40.
Brush drawing, 81 et seqq., 107.
Brushes, 86, 107.

Cadmium, 55, 58.
Cézanne, 45, 97, 102–3, 105, 106, 107, 110–12, 114.
Charm, 35.
Chiaroscuro, 45.
Chinese painting, 105 et seqq.
— perspective, 7.
— White, 70.
Choice, 25.
— of subject, 30.
Circle in perspective, 10.
Claude Lorrain, 33, 90, 94, 103 et seqq.
Cobalt, 58, 69, 74.
Colour, brilliance of, 40.
— complementaries, 49, 55.
— effect, 49, 53.
— harmonies, 44 et seqq.
— idea, 59.
— pure, 49.
— relations, 50.

Colour, rhythm, 60.
— schemes, 51, 59.
— of shadows, 40–1, 48–9, 64.
— simplification, 62 et seqq.
Colour-box, 69.
Complementaries, table of, 55.
Composition, 26 et seqq., 94.
— modification of, 27.
Constable, 100, 109–11.
Corot, 28, 38, 95 et seqq., 109, 110.
Corrections, 84.
Cox, David, 77.
Crimson Lake, 57, 58, 69, 75.
Crone, 109.
Cubism, 28, 107, 111, 114, 115.

Dadaism, 115.
Decorative arrangement, 27, 110, 112, 113.
— idea, 33, 65, 67.
Delacroix, 109.
Detail, 32, 42.
Determination, 24–5.
Distance point, 8.
— — too near, 17.
Drawing, 18 et seqq., 91, 94, 107.
— necessity of, 6.
— tree, 23–4, 102, 104.
Durand-Ruel, 110.

Effect, 33–4, 45–6, 101.
Emerald Green, 71.
Emotion, 36, 42, 108.
Enveloppement, 3.
Equilibrium, 29–30, 101, 105.
Essentials, 30–1, 92, 102.
Expressionism, 115.

Focus, 32, 40.
Foliage, 23, 95, 102, 104.

Foreground, 28, 31–3, 44, 46.
— mountain, 33.
— water, 32.
Form in nature, 18.
— characteristic, 23.
— geometric, 63.
— simplification of, 62, 95.
Fresco, 43, 66.
Frontispiece, 1, 35 *n*., 64, 79.
Future of Art, 116–17.
Futurism, 28, 111, 115.

Gainsborough, 109.
Girtin, 89.
Gravitation, 18, 19.
Greek perspective, 7.
— vase, 43.
Ground-plan, 24.

Habit of simplification, 40.
Half-tones, 41.
Harmonious colour, 46 et seqq.
Hooker's Green, 70.
Horizon line, 8.

Impressionism, 27, 33, 92, 100–1, 110–13.
Indian Yellow, 71.
Interest, point of, 28.

Japanese painting, 105 et seqq., 112, 116.

Leaves, 23, 102, 104.
Light and shade, 42 et seqq.
Light Red, 51, 69, 74.
Lorrain, Claude, 33, 90, 94, 103 et seqq.
Luminosity, 37–9, 46, 47, 49.

Manet, 110.
Massing, 41, 92.
Matisse (Henri), 111, 113–15.
Mauve, 69.
Measuring, 25.
Millet, 109.
Mirror, black, 39–40.

Modelling, 19 et seqq., 92, 95, 97, 108.
— foreground, 13, 31–2, 104, 105.
Monet, 45, 50 *n*., 100, 110, 112.
Morris, 111.
Mountains, 20, 33.

Nude drawing, 18.

Object, main, importance of, 26, 31.
Ochre, Yellow, 51, 58, 69.
Oxide of chromium, 70.

Paper, 77.
Pen, 79.
Pencil, 80.
Perspective, 7, 23, 102, 103.
— Greek, Roman, and Chinese, 7.
Picasso, 111, 114.
Plants, 24.
Plastic conception, 33.
Point of sight, 8.
' Post-Impressionists ', 111.
Poussin, 96 et seq.
Pre-Raphaelitism, 111.
Proportions, 24.
Puvis de Chavannes, 42, 100.

Radiation, 22.
Red, Light, 51, 69, 74.
Reflections, 15, 93–4.
Relation, study of, 5–6.
Relief, 4.
Rembrandt, 42, 43, 45, 92 et seqq., 97.
Renaissance, 109.
Renoir, 100–1, 102, 103, 105.
Reynolds, Sir Joshua, 103.
Rhythm in colour, 54, 60.
— in drawing, 19, 22, 25, 31, 63.
Ripples, 16.
Rocks, igneous, 22, 92, 98.
— sedimentary, 21–2.
Rodin, 111.
Roof in perspective, 10.
Rose-Madder, 55, 69, 74.

Sculpture, Greek, 66.

Sesshū, 105 et seqq.
Shadow colour, 49, 52–3.
— drawing, 13.
— perspective, 13.
Sienna, Burnt, 51, 69, 70.
— Raw, 51, 58, 69.
Silhouette, 46.
Simplicity, 7, 23, 44, 108.
Simplification, 40, 62 et seqq.
Sisley, 110, 112.
Sketch, preliminary, 34.
Solidity in drawing, 19, 32, 95.
Stability, 92, 108.
Station point, 8.
Straight line, 36, 92, 101, 104.
Strata, 21, 92.
Stylization, 33.
Subject, 26 et seqq.
Summary of advice, 63.
Sunlight, 53, 57, 64.
Synthetic treatment, 33, 42.

Technique, 34, 105 et seqq.
Topography, 32, 95, 104.

Tree form, 22, 95, 104.
— type, 23–4, 95.
Trees in perspective, 12.
Turner, 2, 27, 31, 50 n., 60, 66, 91 et
seq., 93, 94, 97, 99, 109–12.

Ultramarine, 58, 69, 74.

Values, 4–5, 32 et seqq., 43, 49, 62, 64.
— measure of, 37.
— scale of, 39.
— table of, 55.
Van Dyck, 5.
Van Gogh, 111–14.
Vanishing point, 9.
Vermilion, Chinese, 55.
Viridian, 70, 74.

Wash, 82, 85, 106–7.
Water, 15–16, 93–4, 102.
Whistler, 112.
Wint, Peter de, 95.

Yellow Ochre, 51, 58, 69.

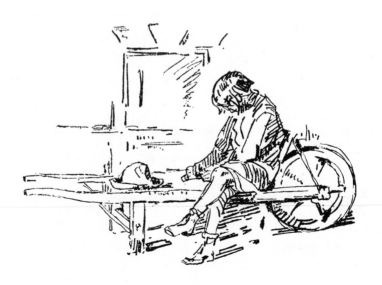